Logo Construction

Logo Construction

How to Design and Build a Logo

Paula Yacomuzzi

HARPER
DESIGN
An Imprint of HarperCollinsPublishers

Logo Construction.
How to Design and Build a Logo

First Edition:
Published by **maomao** publications in 2012
Via Laietana, 32 4th fl. of. 104
08003 Barcelona, España
Tel. : +34 93 268 80 88
Fax : +34 93 317 42 08
www.maomaopublications.com

English language edition first published in 2012 by:
Harper Design
An Imprint of HarperCollins*Publishers*,
10 East 53rd Street
New York, NY 10022
Tel.: (212) 207-7000
Fax: (212) 207-7654
harperdesign@harpercollins.com
www.harpercollins.com

Distributed throughout the world by:
HarperCollins*Publishers*
10 East 53rd Street
New York, NY 10022
Fax: (212) 207-7654

Publisher: Paco Asensio

Editorial Coordination: Cristian Campos

Editor and texts: Paula Yacomuzzi

Translation: Cillero & De Motta

Art Direction: Emma Termes Parera

Library of Congress Control Number: 2012932386
ISBN 978-0-06-200459-8

Printed in Spain
First Printing, 2012

Contents

8 **Introduction**

12 **256 Hennessey Road**

16 **3030 Press**

20 **Accesspoint**

24 **Alchemy**

28 **Architect Stadt Munster**

32 **Arthur Mebius**

36 **Arts Santa Mònica**

42 **Atelier 9.81**

46 **Avex**

50 **Banjo Music**

54 **Banneitz Coaching**

58 **Beyond Risør**

64 **Business to Arts**

68 **Casa da Música**

74 **Charmingwall**

78 **Circus**

84 **Circus Hein**

88 **Dare 2 Records**

92 **Depeche Mode's *Sounds of the Universe***

96 **Design (Re)Invents**

102 **Design 360°**

106 **DOT Baires shopping mall**

110 **Dr. Nick Lowe**

114 **Dreispitzhalle**

120 **Durable, Sustainable, Desirable Architecture**

124 **DW Design Group**

130 **Edge of Europe**

136 **Eight**

140 **Electric Cinema**

144 **EMPO School of Organic Osteopathy**

148 **Estudi Artik**

152 **Feesability**

156 **FH Mainz University of Applied Sciences**

160 **FutureCraft**

164 **Gira**

170 **Horror Vacui**

174 **IDTV**

178 **International Film Festival Rotterdam**

184 **Lab111**

188 **Lange Nacht der Opern und Theater**

192 **Luigi Bosca**

196 **Made in Me**

202 **My Fonts**

206 **New York's Museum of Arts and Design**

210 **Nippon Sense**

214 **North Ridge Films**

220 **Nuno**

224 **Paris Fashion**

228 **Pedro García**

232 **Pfalztheater**

236 **Poudre River Public Library**

240 **Proyecta Visual**

244 **Rebekka Notkin**

248 **Ro Theatre**

252 **Ruhr Museum**

256 **Sandberg Institute Amsterdam**

260 **Sculpture International Rotterdam**

266 **Seeleninsel**

270 **Start Milan**

274 **TESS**

280 **The See**

286 **The Tone Travellers**

290 **The Urban Craft Center**

294 **Tijdelijk Museum Amsterdam**

298 **Tissa**

302 **Vortex**

308 **Walter Chiani and Cedric Chappey**

312 **ZeroCarbonCity**

316 **Znips**

Introduction

This book is a compilation of a diverse variety of internationally renowned studios, as well as new studios, that stand out in the current landscape of visual identity design. All of the designers listed within these pages have provided the artwork of their best logos from the past five years, establishing this collection at the forefront of the most current values in graphic branding. However, the focus of this book is not on the trends in logo design, but rather the diversity and richness of each designer's unique creation process.

Every design studio represented in this book has provided insight into their work process, from the initial research stage, to the development of a conceptual idea, and finally, to the physical creation of different designs; shaping them and altering them, until they have come up with a single design they feel best represents the client. Some designers, who go directly from the research stage to the development stage, have been more limited in the examples they could provide, while others have retrieved pages and pages of sketches and even doodles, to showcase the multiple stages of development.

Within these pages, all the nuances of graphic manipulation and logo design can be seen through each individual designer's work. Some studios are so devoted to the creation

of a logo that they turn to the real world, working with cards, fabrics, and furnishings to develop models which are then photographed. Other studios deliberate over a single graphic idea and then question, rethink, indulge, and polish it until they feel it is perfect.

Our goal in creating this book is to document the dynamic methods of logo construction many of the leading designers use today, which are as rich as they are diverse. During our rigorous selection process, we chose designers we believed had something important to illustrate about the genesis and evolution of a logo. This book is a testimony to the ways logos are created and developed, and is aimed for a reader who, rather than being satisfied with formulas, is interested in scrutinizing the real material and making up their own mind about what they see. From the rich and accurate textual and graphic material presented, readers can discern what approaches are most appropriate for certain projects and, if they are interested in discovering a more effective procedure, they may do so according to their own preferences.

One of the limitations we had in the development of this book was finding existing material—that is, the physical and digital material that has survived at the end of a project. Many award-winning logos were excluded because their documentation was scarce or nonexistent. Much of the graphic information that we sought, such as sketches of ideas that have not reached advanced stages or been developed in detail, was simply of little worth compared to that which was systematically documented.

Within the pages of this book, we hope to present to readers rich artwork on logo design, and offer an experience as authentic as each of the following sketches.

What the reader should know before starting
For the fully conceptual projects, we present real-life items or graphic-style images that have served as inspiration. The concept of inspiration is understood in a broad sense, ranging from the attraction to an image, object, or style, to its reformulation or stylization, to the effective stimulus that helps to produce it in a spontaneous and fluid way. On some occasions, the images have been produced expressly for our book so that we get an idea of what was going on in the heads of the designers. We hope that all these images will help in understanding specific approaches to logo design.

MyFonts

beyond risør

Eight

MyFonts®

MAD
museum of arts and design

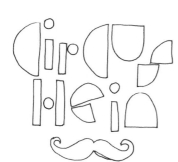

LAB¹¹¹

NUNO

FH MAINZ

DESIGN
(RE)INVENTS

The logos

TWO ¦ FIVE ¦ SIX

TWO ¦ FIVE ¦ SIX

256 Hennessey Road

The logo for this interesting building, which brings together
commercial offices, entertainment spaces, and art galleries,
directly points to the property that it represents, located at 256
Hennessey Road in Hong Kong's revitalized Wan Chai district.
It does this by adopting the building's verticality and its main
architectural feature—a chain of long skinny windows crawling
up all sides of the skyscraper—while usefully highlighting the
building's address graphically.

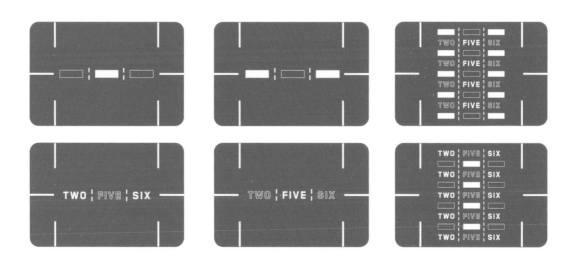

milkxhake

Milkxhake is a Hong Kong-based design unit co-founded by graphic designer Javin Mo and interactive designer Wilson Tang in 2002, mainly focusing on graphic and interactive mixtures.

www.milkxhake.org

Where did you draw inspiration from for this project?
The simple TwoFiveSix logotype, inspired from its architecture, easily demonstrates the idea of giving an identity to architectural appearance through the use of vertical blocks. Two main versions of this identity were implemented equally across all applications, providing a visual identity system for TwoFiveSix.

What lessons have you learned about logo design or what do you wish you had known?
Mutual respect is crucial in designing a logo. It is not simply about the designer's preference, a successful outcome can only be achieved through good collaboration and understanding between the client and the designer.

What advice do you have for other designers?
Always listen carefully to the client's needs, then do good research before you start the design process.

TWO ⦂ FIVE ⦂ SIX

The building's well-known visual brand is easily used to create a vibrant graphic pattern when the logos are connected. The color red comes from the identity of the real estate group that owns and developed the building.

BETTER
WORKING SPACE

—

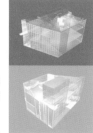

OUR VISION

TWOFIVESIX is a contribution of better space to the community.

The high-rise building is not only a remarkable commercial structure redefining the Wan Chai skyline, it is also a pioneer of creative design and an ideal conception of the urban lifestyle.

The retail-cum-commercial project is conceived with top quality materials, sophisticated design and user-friendly layouts and amenities, sensitive to the way modern people live and conduct business.

AT A GLANCE

The iconic tower is strategically located between Hennessy Road and Johnston Road, at the heart of busy Wan Chai and a few steps away from the MTR.

TWOFIVESIX will rub shoulders with a myriad of buildings, yet is the first of its kind in the neighborhood it has to offer.

- Five-metre high retail floors
- Restaurant floors with an average ceiling height of 4.5m
- Fancy office lofts with soaring ceilings

簡談

TWOFIVESIX 締造美好社區空間。

多元經營的高聳大廈成為醒目的新地標，更重新塑造了灣仔的城市輪廓，為創意設計及理想生活模式領軍的作品。

本項綜合建築薈萃優質而多變元素，貼近合一致的設計、精巧的設計、體貼的佈局及完善設備，令現代「活」、「工」上班一族輕鬆愉快地掌握現代都市節奏及生活。

高樓式的商業匯集集的財富創造亮點，貼近城市脈搏，鄰近繁華地段亦更是逛街之選。

TWOFIVESIX 都會融入人潮匯集的鄰近街市，是眾多特色餐廳中之嶄新獨家之作。

- 五米高的零售商層層獨關
- 平均樓面高4.5米高的多樓層餐廳
- 樓底高企、設計別緻的辦公層

WE LOVE TO
CREATE

—

INTERVIEW WITH CL3 WILLIAM LIM

CL3 - THE ARCHITECTURE FIRM AND INTERIOR DESIGN FIRM FOR TWOFIVESIX

Describe your feelings toward Wan Chai.

I think Wan Chai is probably one of the most dynamic districts of HK Island. It goes from the historic part with a lot of interesting architectural elements, such as the Wan Chai Market, the Blue House and the Hung Shing Temple, to the new part up North where the Hong Kong Convention and Exhibition Center is. It has variety within the area,and a lot to offer from very chic, high-end area near the Star Street to the bar district on Lockhart Road. It has the full spectrum that represents Hong Kong.

What was your major idea when designing TWOFIVESIX?

We want to create a hype within this area. I think the idea is to create a focus within the neighborhood that will become an icon. That's really how we set out designing the project. We looked at the urban fabric in the area and the surrounding buildings, which has an interesting mix of residential, offices, commercial area and the street market. We want to create something that is pure in form that suits itself apart from the environment.

What were your important consideration(s) when designing TWOFIVESIX?

Well, first of all it needs to be a very appealing product. It's something that has to be very different from what's in the market.

Actually we made use of our strength, which a lot of people know CL3 as an interior design firm, and did the whole project looking at it from the inside out and then outside in(which I think, is a very unique way of looking at architecture in Hong Kong. A lot of times, we see a building with its exterior, but then it really has nothing to do with the interior. Here, we have an opportunity to look at the tower as a whole and to see how it can adapt and appeal to our modern lifestyle.

From a designer's point of view, we have places in New York, London, where the older district is being revitalized and turned into the hip part of town. I see Wan Chai as a perfect place for that kind of urban renewal and we see that when considering this project. We think of how to inject new energy into the district.

我認為灣仔可算是香港島最具活力的地區之一，與擁有了很多古舊而有趣的建築元素，如灣仔街市、藍屋及洪聖廟等的歷史性地帶，以至北面全新的香港會議展覽中心。這區內既包含Star Street的一帶時尚、高尚地段，亦有Lockhart Road的酒吧區，是最能代表香港的地區。

3030 Press

After a lot of testing and development in search of a suitable typeface for the logo redesign for 3030 Press, a publisher of books on contemporary art and design from China, an ITC Conduit was selected for the distinctness of its number three. This unusually pleasing form provided the temperament and indelible readability the designers sought. The composition of the three within a circle, which also refers to the zero in the publisher's name, was the element that milkxhake came up with to give the brand a contemporary rebirth.

John Millichap
Publisher

Rm.1901, Bldg.10, 428 Changping Rd,
ShangHai 200040, PR China
中國上海市昌平路428号
10号樓閣1901室200040
T: 86 21 6267 7990 / F: 86 21 5228 6705
M: 86 0 1365 1384 514
E: john.millchap@3030press.com

Rm. 602, Wah Yuen Bldg.
149 Queen's Road Central, Hong Kong
T: 852 2139 3396

3030Press

milkxhake

Milkxhake is a Hong Kong–based design unit co-founded by
graphic designer Javin Mo and interactive designer Wilson Tang
in 2002, mainly focusing on graphic and interactive mixtures.

www.milkxhake.org

What is your personal design process?
Research and development, symbol or logotype, black and
white or color, *Helvetica* or *Bodoni*, vertical or horizontal . . .

Where did you draw inspiration from for this project?
Inspired from a traditional stamp, the logo for 3030 Press
is very simple. It is comprised of the numerals three and
zero, drawn from the name, while the red color and the outer
circle depicts the contemporary Chinese accent, focusing on
the vision of art and design from China.

**What lessons have you learned about logo design or what do
you wish you had known?**
Research has become the most important step in designing
a logo. You should listen to the client brief and start your
research before any development. Without research, you will
not be able to understand more about your client. Research
is always the first step for me in any logo design project.

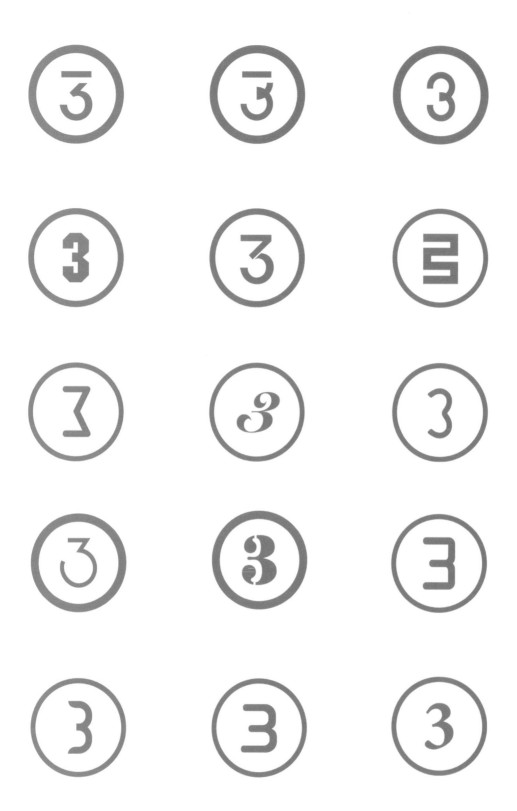

Given the name of the press, the numbers three and zero were an obvious starting point for milkshake. After looking at a number of very different typefaces, they decided to work with one that allowed the round form of the zero to be echoed by the three (rather than a typeface that presented an angular and straight-edged version of that numeral).

Accesspoint

Accesspoint

Accesspoint is a cloud-and utility-computing services provider offering business-to-business services. For the design of Accesspoint's identity, the Barcelona company Ummocrono worked to understand graphically the structure and operation of the technology company. The designers discovered that, because of Accesspoint's distance from the end consumer, the graphics had to be clear and simple, and should emphasize the company's mission. In the final logo, two elements stand out: the letter i's dot in a surprising position, and lowercase letters as tall as the capital A preceding them—all of which lead the viewer to easily see the access point.

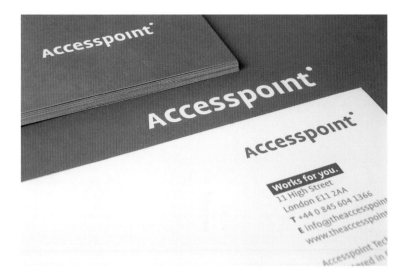

Ummocrono

Ummocrono is a Barcelona-based, cross-media design and branding company.

www.ummocrono.com

What are the basic rules of logo design?
In addition to communicating to viewers, the logo should be scalable and function in all types of applications, whether printed, on-screen, photocopied, and so on. The logo is also part of a larger context—the visual identity—and should lend itself to, and fit, in a wider visual language.

Where did you draw inspiration from for this project?
During this work with Accesspoint, we discovered a reference to a geographic location near Antarctica called Accesspoint. It was indicated on the map by a simple point. Perhaps that inspired us.

What lessons have you learned about logo design or what do you wish you had known?
Nina Wollner: To always keep the client's needs and their market in mind, and the first ideas are sometimes the best.
Fredrik Jönsson: A logo is nothing in itself. The way meaning and value is invested and attached to a logo and an identity is what matters.

access ●

[]

ACCESSPOINT● .—●

[] accesspoint

accesspoint.

point

point.

accesspoint.

ACCESSPOINT

accesspoint ●

accesspoint●

The first sketches were, in part, an attempt to display the
company's structure. In an effort to not overcomplicate
the visual field, the designers at Ummocrono chose to simplify
their concept. The final logotype doesn't try to represent
Accesspoint's structure literally, but works on a more
metaphorical level to convey the spirit of the company and
their methodology.

accesspoint● X too thin

accesspoint●

accesspoint●

↕ to use white on
colour, bold required?

accesspoint● ← too bold

counter closes

BLACK

ACCESSPOINT● MAKES NO
LOGIC SENSE!

Accesspoint●

too weak! → **Accesspoint**●

still a bit
too small?
open the → **Accesspoint**●
counter?

A●↑

A●

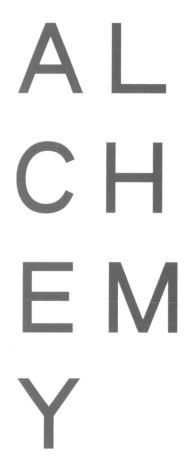

Alchemy

Alchemy is a Japanese magazine focused on the design business in Asia, published by a+u Publishing. The medieval art of alchemy is considered the forerunner of modern chemistry and involved, it was believed, the magical transformation of base materials into gold; the prosaic into the precious. The magazine, which considers design in these terms, was looking for a logo and header that was an alchemical combination of otherwise disparate elements: east and west, prose and poetry, pedestrian and spectacular.

Issue #6:
p. 6: Interview with Ong Beng Seng
The CEO talks about the Asian Wireless acquisition and how he's moving to keep abreast of cable competitors

p. 9: Buy On Weakness
The value stocks favored by Greedy, Brown haven't done well lately

Tech in Taipei
World loves gadgets: Buy the stocks of companies

(NEW) ASIAN DESIGN BUSINESS PAPER
VOLUME 1
PRICE: FREE

Florian Mewes

Originally from Berlin, Germany, Florian Mewes is a graphic designer living and working in Amsterdam. In 2011, he teamed up with Dutch designer Arjan Groot to form Groot/Mewes, a firm specializing in conceptually rigorous yet accessible design.

www.grootmewes.com

What are the basic rules of logo design?
Actually, I don't like logos. They are like medals and badges from historic dynasties and old-fashioned fraternities—we always put them in the same corner, trying hard to mark our territory like a dog does, whereas a dog is less limited and thus more efficient. I like very open identities that are not hooked on one logo or on fixed positions of graphical elements, yet are still strong and highly recognizable. The stronger the concept and the better the design, the less rules you will need.

Where did you draw inspiration from for this project?
The inspiration always comes from the content. I avoid having an image in my head when starting a design. With *Alchemy*, chemistry and Asian culture were the starting points that defined the form of the logo.

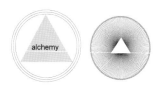

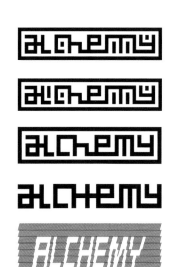

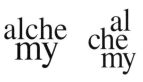

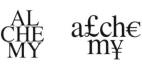

Alchemy + Alchemy +
Alchemy + Alchemy +
Alchemy + Alchemy =

Alchemy

Alchemy

Al	AL	AL
Ch	CH	CH
Em	EM	EM
Y	Y	Y

AL	AL	AL
CH	CH	CH
EM	EM	€M
Y	Y	¥

Mewes began by looking at and working with images inspired by alchemy's roots in mysticism and the iconography of long-forgotten quasi-magical practices. In addition, the Dutch designer was inspired by the Japanese tradition of tategaki, which organizes writing into vertical columns that are read from left to right and top to bottom. Mewes tied the idea of tategaki to modern chemistry's periodic table in laying out the letters of his logotype in a vertical fashion that is highly structured yet surprising. In choosing his typeface, Mewes again turned to Asian influences by utilizing Li Hei, one of the standard fonts packaged with Macs sold in Asia and an analogue to Times Roman, but rendered somewhat clumsily to a Westerner's eye—a crudeness that, according to Mewes, is not without its charm.

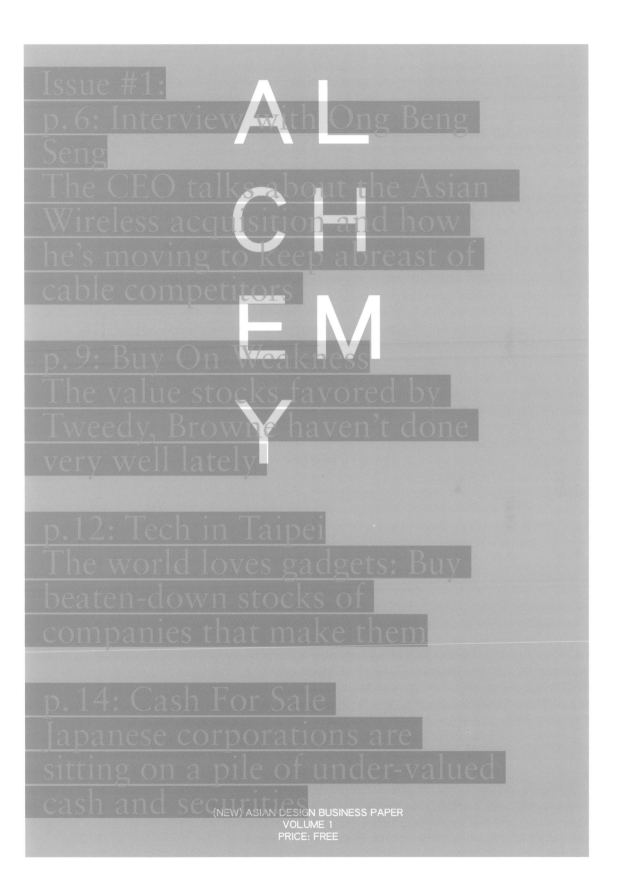

ALCHEMY

Issue #1:

p. 6: Interview with Ong Beng Seng
The CEO talks about the Asian Wireless acquisition and how he's moving to keep abreast of cable competitors

p. 9: Buy On Weakness
The value stocks favored by Tweedy, Browne haven't done very well lately

p.12: Tech in Taipei
The world loves gadgets: Buy beaten-down stocks of companies that make them

p. 14: Cash For Sale
Japanese corporations are sitting on a pile of under-valued cash and securities

(NEW) ASIAN DESIGN BUSINESS PAPER
VOLUME 1
PRICE: FREE

Architect Stadt Munster

The silhouette that contains the name is derived from and, simultaneously, refers to a multitude of references. The three-dimensionality of architecture is initially evident, as it is a logo for an organization promoting that form in Munich, through conferences, excursions, and exhibitions. But the silhouette also represents the interplay of light and shadow and even, perhaps, an unusual comic book inspired bubble suggestive of one of Architect Stadt Munster's core missions: dialogue. The starkness of the white on black logo against the almost shockingly bright colors of the organization's materials creates an image the viewer cannot ignore.

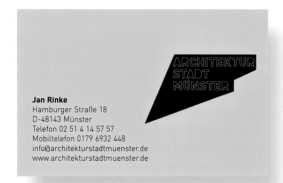

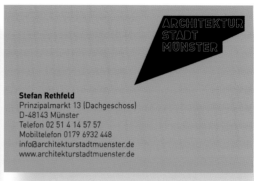

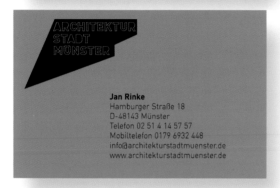

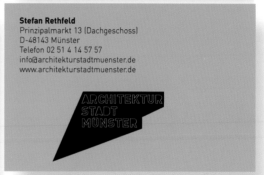

Brighten the Corners

Brighten the Corners is an independent, multi-disciplined design and strategy consultancy firm with offices in London and Stuttgart.

www.brightenthecorners.com

What is your personal design process?
1. Thinking
2. Making
3. Tidying up

Where did you draw inspiration from for this project?
For this project for Architektur Stadt Münster, we were inspired by the title sequence in Monty Python's *Life of Brian.*

What lessons have you learned about logo design or what do you wish you had known?
Perhaps it's a bit old-fashioned of us, but we always work toward a black-and-white logo. This helps us focus on the marque itself, and this will usually result in a better logo. Then color can always come in later if there's a job for it to do.

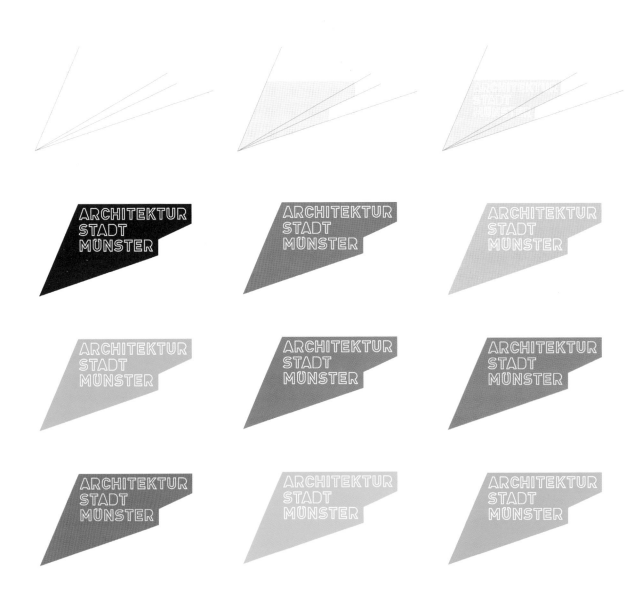

This now iconic silhouette is a centerpiece of the image. It is versatile in its use as it expands across the plane and into, seemingly, three dimensions.

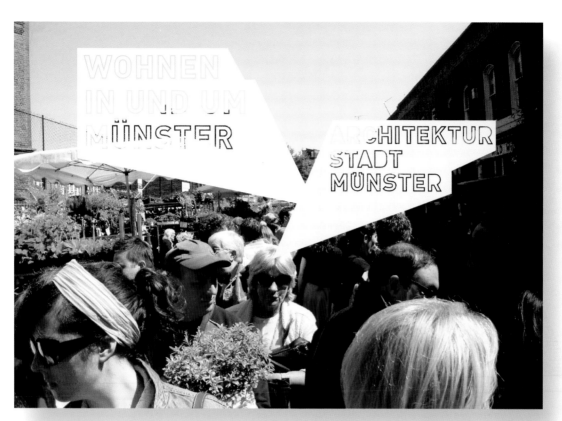

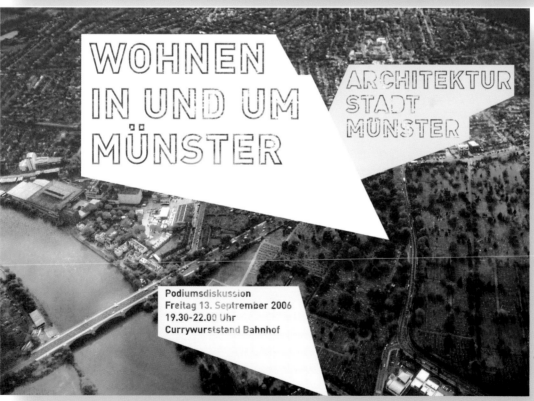

ARTHUR MEBIUS PHOTO GRAPHY

Arthur Mebius

The advertising photographer Arthur Mebius was looking for
a logo to complicate his proposed slogan: "sharp pictures."
Mebius' work is highly theatrical, often presenting colorful,
whimsical scenes in which his subjects comically perform for
the camera, often with a wink. Dutch designer Arjan Groot tried
a wide variety of solutions trying to match wits with Mebius'
always witty images. In the end, he discovered that these
photographs created a world of their own, and could only be
defined in the idiosyncratic terms of their creator, leading him
to design a logo without an icon but with a new, refreshingly
straightforward slogan—a Futura in black with horizontal lines
and the highlighted text: A Mebius Photo.

Arjan Groot

Arjan Groot is an award-winning graphic designer based in
Amsterdam. He is also the co-founder of the architecture
journal *A10*.

www.arjangroot.net

What is your personal design process?
Studying the brief (or writing one), submerging myself in
information about the client's specialization, making lots of
sketches, visualizing every intuitive association and every
formal variation that seems interesting, asking colleagues
for feedback, looking at my ingenious design again the next
day, then admitting it seemed better the day before.

Where did you draw inspiration from for this project?
I was inspired by Arthur Mebius's photography, by a
photographic symbol in which I recognized my client's
initials, and by heraldry—I suppose it was evoked by my
client's "royal" first name.

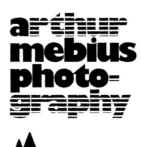

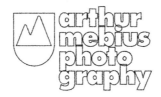

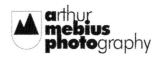

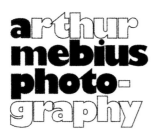

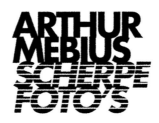

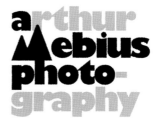

Arjan Groot began by looking at the typical symbols of camera settings: landscape, portrait, bright light, overcast, and so on. The landscape icon initially interested the designer for it's potentially multiple signifiers: photography, the letter *M* (the first letter of the photographer's surname), the Swiss Alps (a personal passion for Mebius), and even a handkerchief in a man's suit (representing, perhaps, the urban sophistication of Mebius' photos). However, neither this icon, nor any of the others, adequately reflected Mebius' work which was neither landscape, nor portraiture. Indeed, the work was truly in its own class and no logo from the world of photography could represent it perfectly. What could? Only the photographer's name, laid out in a visually cunning way, would do.

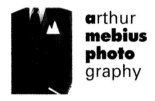

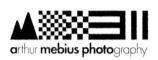

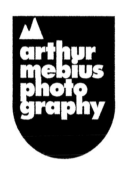

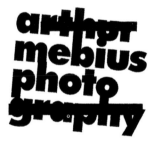

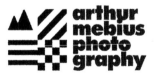

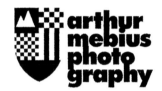

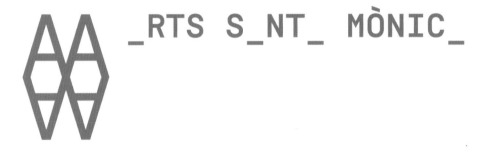

Arts Santa Mònica

Contrary to what is often advised in logo design, the icon and text of Arts Santa Mònica have equal graphic weight in their new identity designed by Cla-se. However, instead of competing, they complement each other. The four letters A's missing in the name of the contemporary cultural center of Barcelona are intertwined in a symbol that reflects the visual poem. An A for each discipline: art, science, thought, and communication. The icon, in ink and either expanded or multiplied, is a blatant declaration on posters, banners, or the walls of the institution. The typeface is the brainchild of Iñigo Jerez, and was created specifically for this project.

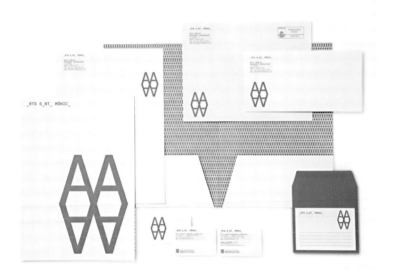

Cla-se

Cla-se is an award-winning Barcelona-based full-service design firm.

www.clasebcn.com

What is your personal design process?
Our work process is to research the environment in which the design has to function, study the background—in the case of a redesign—and open several project options without having too many prejudices about the results to filter them later. A good presentation of the work process to the client is very important to understanding how you have come up with the best solution.

Where did you draw inspiration from for this project?
For the Arts Santa Mònica project, no specific influence can be pinpointed. Perhaps the visual poetry has been a referent.

What advice do you have for other designers?
Go back to the basics. Don't complicate things for no reason.

_RTS S_NT_ MÒNIC_
COMUNIC_CIÓ

_RTS S_NT_ MÒNIC_
PENS_MENT

_RTS S_NT_ MÒNIC_
CIÈNCI_

S_NT_ MÒNIC_
___ CIENCI_
PENS_MENT
COMUNIC_CIÓ

_RTS S_NT_ MÒNIC_

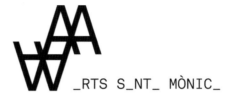

During the design process, Cla-se and the directors at Arts
Santa Mònica identified early on that both a graphic and
a logotype was desired, and that these should be able to
function independently as well as together. Through a number
of sketches, the four A's were extracted from the center's
name and repurposed to create a fitting but, in some ways,
intriguingly counter intuitive symbol. The fact that the graphic
and the text completed each other was the perfect metaphor
for the trans-disciplinary and cross-platform work of Arts
Santa Mònica. Additionally, in the interest of engaging with
the center's drive for innovation, a new typeface was created
specifically for the project by Cla-se designer Íñigo Jerez.

_RTS S_NT_ MÒNIC_

S_NT_ MÒNIC_
_RTS

_RTS
S_NT_ MÒNIC_

A

_RTS S_NT_ MÒNIC_

A

A___
S_____
M_____

ARTS SANTA MÒNICA

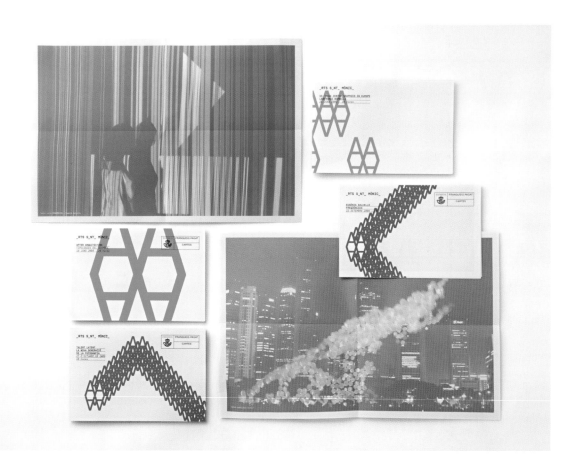

_RTS S_NT_ MÒNIC_

JUNY-SETEMBRE_09

20 JUNY - 06 SETEMBRE
AFTER_ARCHITECTURE
TIPOLOGIES DEL_DESPRÉS
UNA EXPOSICIÓ DE PROJECTES DE 17 ARTISTES QUE REFLEXIONEN
SOBRE LA CONSTRUCCIÓ ARQUITECTÒNICA

26 JUNY - 20 SETEMBRE
ARQUITECTURES
SENSE_LLOC_1968-2008
200 PROJECTES D'ARQUITECTURA NO EXISTENT

26 JUNY - 20 SETEMBRE
US_TRADE_CENTER_GRAPHICS
IN_EUROPE
LANFRANCO_BOMBELLI
ESBOSSOS PER A LA GRÀFICA DELS CENTRES COMERCIALS AMERICANS A EUROPA
(1967-1977). UNA INSTAL·LACIÓ DE TOM CARR

26 JUNY - 25 OCTUBRE
A_GREEN_NEW_DEAL
ENRIC_RUIZ-GELI
PROJECCIÓ/EXPOSICIÓ/INTERVENCIÓ ARQUITECTÒNICA
EFÍMERA A FAÇANA

ARTS SANTA MÒNICA
LA RAMBLA 7 / 08002 BARCELONA / T 93 3162810
DIMARTS A DIUMENGE 12.00H-22.00H / DILLUNS TANCAT
ENTRADA LLIURE / ENTRADA LIBRE / FREE ENTRY
<M>L3 DRASSANES, <P> BICING
WWW.ARTSSANTAMONICA.CAT

ATELIER 9.81

ATELIER D'ARCHITECTURE
ET D'URBANISME

Atelier 9.81

The logo for Atelier 9.81, an architecture and urban design company, was conceived in conjunction with the development of their website, by Les produits de l'épicerie. The figure 9.81 in the name refers directly to the coefficient of gravity, so the designers experimented with a typographical logo that seemed to contain mass, volume, and movement. While on the website the logo is animated, showing it frenetically shape-shifting, perhaps defying gravity, to rest only momentarily in what is its fixed state on paper. That fixed state is the four parts of the figure—three numbers and the decimal point—rendered as almost amorphous blobs that are intentionally difficult to read immediately, and which the eye perceives at first as merely a visually intriguing image before it understands them as the numbers of the company's name.

Les produits de l'épicerie

Les produits de l'épicerie is a graphic design studio based in Lille, France, founded in 2003 by Philippe Delforge and Jérome Grimbert.

www.lesproduitsdelepicerie.org

What is your personal design process?
Very often, we start to work like a game. In this process, we define one or two concepts (rarely more) for how we can move the various types, and we play until we find something that is well balanced and easy to manipulate.

Where did you draw inspiration from for this project?
I don't think there is something or someplace that can inspire us in creating logos. Obviously we admire certain projects of certain designers or artists or musicians, but this is not the genesis of our work.

What lessons have you learned about logo design or what do you wish you had known?
During all this time dedicated to the creation of logos and visual identity, we have learned how important it is to always have the notion of "visual economy" in our mind. Even though we attempt to not be too "dry" or "poor" in our design, minimalism, simplicity, and rigor are our real goals. Each logo is a new project, so it is a new game with new pieces.

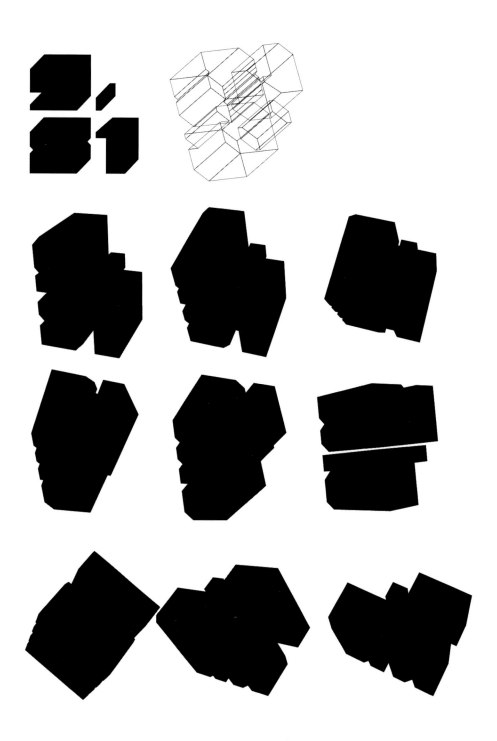

The sign, which is lively on the website, loses its typographical roots. The icons that identify each studio project are typical of its aesthetic.

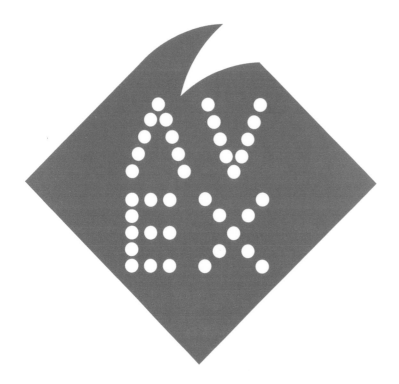

Avex

Avex is a poultry farm in Cordoba, Argentina, and its business includes everything from egg production to the marketing of processed foods. The presence of the rooster's crest in the Avex logo is an open evocation of that proud bird which is an obvious symbol for the company. The color red not only evokes the rooster, but lends a certain strength and virility to the company, while the modern dot font nestled within that color field signifies Avex's place in contemporary society, unlike other, more traditional farms. The image of this poultry company has been created by Diseño Shakespear, who also made the signage for the company's industrial buildings.

Diseño Shakespear

Lorenzo Shakespear / Juan Shakespear / Ronald Shakespear / Martina Mut / Eliana Testa / Gonzalo Strasser / María Spitaleri / Claudio Sarden / Juan Hitters / Héctor Calderone

Diseño Shakespear is a Buenos Aires–based branding, marketing, and design firm.

www.webshakespear.com.ar

What is your personal design process?
Many customers ask us for a boat, but what they really need is a way to cross a river. Our task involves defining the client's goals and providing solutions.

What lessons have you learned about logo design or what do you wish you had known?
Fifty years ago, I ignored the fact that most logos are not everlasting. On the contrary, their functionality has a limited life, owing to their public acceptance and strategic character needs. The great lesson has been that logos often arouse love and hate in the public, and this, and only this, warrants their useful life.

What advice do you have for other designers?
I have taught design for years at universities in Argentina, the United States, Mexico, and Canada. The most frightening experience is when students are faced with a blank sheet—in design we call it "the black box of creativity." The search for visual ideas demands a methodological process that involves background research, analysis of competition, and the gradual advance of the draft.

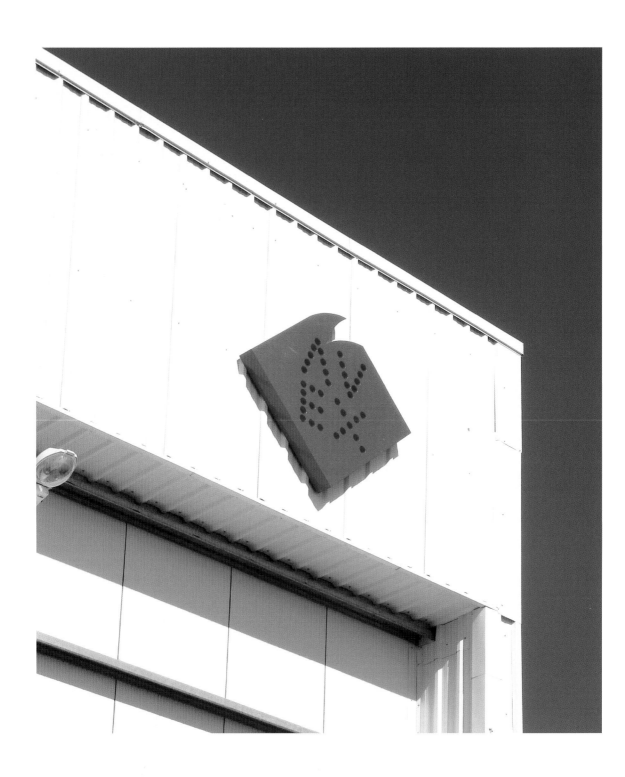

The Avex logo has elements that are repeated elsewhere in the company's identity: the color red, the dot font, and the diamond.

Avex Branding
Design: Lorenzo, Juan y Ronald Shakespear
Year: 2009
Staff: Joaquin Viramonte/ Mario Spitalero/ Martina Mut /Eliana Testa /Claudio Sarden /Gonzalo Strasser /Gabriela Fiorio/ Belen Amadeo Ladina/ Lucia Diaz Manin
Diseño Shakespear Argentina
www.shakespearweb.com

Avex Branding
Design: Lorenzo, Juan y Ronald Shakespear
Year: 2009
Staff: Joaquin Viramonte/ Mario Spitalero/ Martina Mut /Eliana Testa /Claudio Sarden /Gonzalo Strasser /Gabriela Fiorio/ Belen Amadeo Ladina/ Lucia Diaz Manin
Diseño Shakespear Argentina
www.shakespearweb.com

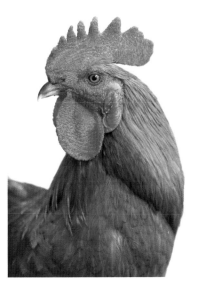

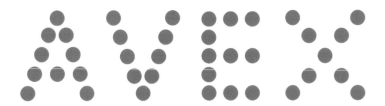

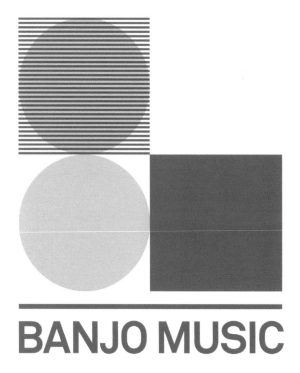

Banjo Music

Resting on a stable grid, the combinations of simple geometric figures in black and white, or in a limited but evocative palette of purples and sea-foam green, provides a richness of variety and a clear visual language that ensures brand recognition. Flexibility is the main value at work in this dynamic system which give Banjo Music, a music production company known to create a unique sound for each project they work on, immediate visual identification to match their musical output.

TwoPoints.Net

TwoPoints.Net is a Barcelona and Berlin based design company directed by Lupi Asensio and Martin Lorenz, two graphic designers with German, Dutch, and Spanish education and experience.

www.twopoints.net

What are the basic rules of logo design?
Well, we do not do logo design; we think the common logo is anachronistic. This might sound a bit arrogant, but what we are trying to convey is that there is so much more possible nowadays. Now, liquid identities are able to meet the demands of a modern company.

Where did you draw inspiration from for this project?
The grid, from which we derived the basic elements of the visual system, is based on the construction of the Roman Capitalis from 600 BC, which in turn was based on Etruscan and Greek letters and was reinterpreted by (for example) Albrecht Dürer in 1525, Grandjean de Fouchy in 1692, and Paul Renner with Futura in 1927, among others.

What advice do you have for other designers?
Don't think of the logo as a static image; think of it as the outcome of a flexible system.

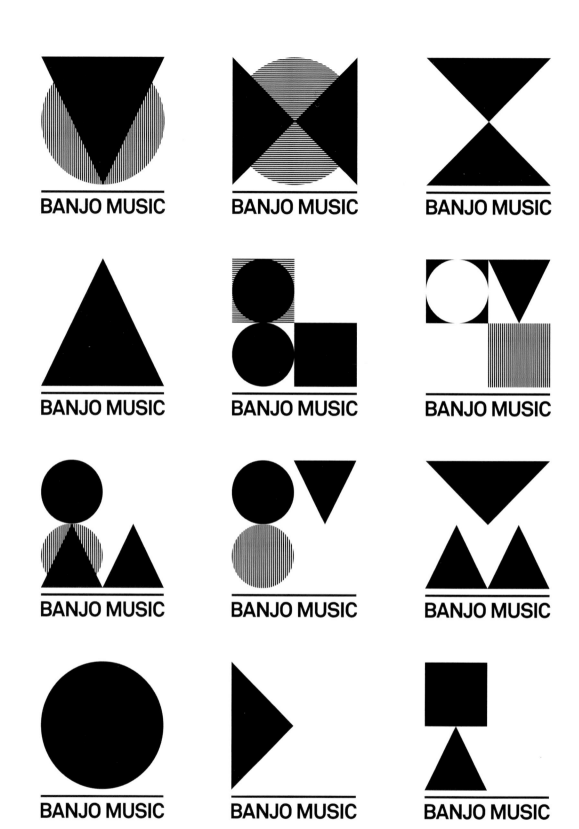

In addition to setting the type in *Roman* capitals, TwoPoints.Net was inspired by a musical notation system known as Graphic Notation that represents music in terms of colored shapes on a grid.

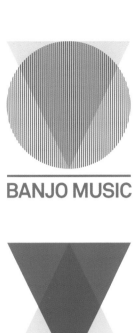

BANJO MUSIC

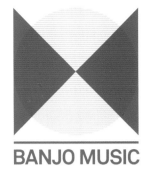

BANJO MUSIC

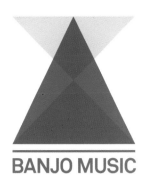

BANJO MUSIC

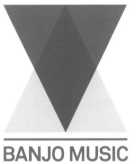

BANJO MUSIC

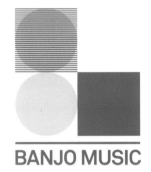

BANJO MUSIC

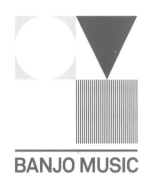

BANJO MUSIC

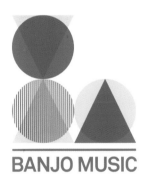

BANJO MUSIC

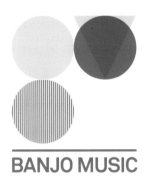

BANJO MUSIC

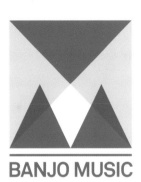

BANJO MUSIC

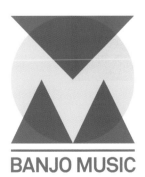

BANJO MUSIC

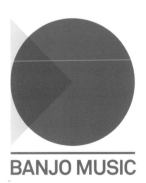

BANJO MUSIC

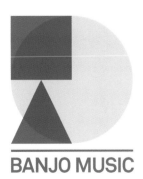

BANJO MUSIC

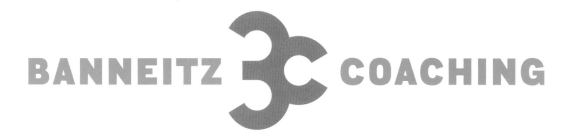

Banneitz Coaching

Banneitz Coaching is a consulting firm dedicated to helping businesses achieve their goals through team-building, dynamic leadership, and finding the energy to solve problems. It is Banneitz's dynamism, passion, and energy for their work that inspired Claudius Design's first graphical take on a logo in the form of waves as representative of these positive vibrations. The client, however, thought this approach was overly technical. In a radically different approach, Claudius played with geometric patterns and the relationship between the letters B and C in the name, to create a logo that contained one of the client's hallmarks: direct communication.

Claudius Design

Claudius Design is a graphic design firm based in Essen, Germany, led by Stefan Claudius.

www.claudius-design.de

What are the basic rules of logo design?
Concentration is the most important thing. There is no development in the perception of a logo. You see everything at once, in contrast to a book, where you can show one graphic element after the other. A logo must contain everything you want to tell at the first glance. It is a highly concentrated piece of design—the tip of an iceberg. Behind it stand an enterprise, a philosophy, thoughts and considerations, and many rejected logos that nobody will ever see.

Where did you draw inspiration from for this project?
The final logo was influenced by my research for the term *coach*. Of course there is the brand of bags with its rather traditional horse-and-carriage logo, but on the client's website there was a background with a kind of Gucci-type logo. The parallel between those two things resonated with me, but unconciously.

What lessons have you learned about logo design or what do you wish you had known?
I learned to focus my ideas, and in most cases, less is more. Two ideas in one logo can often be too much, as they can compete for attention. Instead, all aspects of a logo should work together.

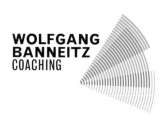

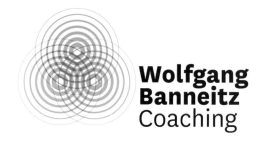

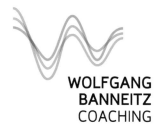

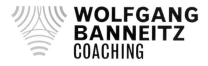

While the designer's first attempt at the logo in the form of multi-colored waveforms seemed too technical for the client, it did begin to suggest the major remit of Banneitz Coaching, the importance of communication. In other early versions of the logo, Claudius Design created more abstract imagery that still implied relationships between similar objects. The designers were able to pinpoint a color scheme that worked for the client that was at once subtle, off-beat, and attention-grabbing. Finally, the designers—working in a simplified version of that color scheme—discovered the relationship between the first letters of the company's name created the most direct way to communicate their ideas, as well as Banneitz Coaching's brand.

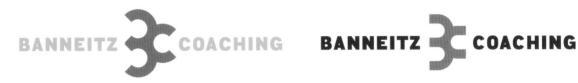

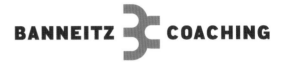

beyond risør

Beyond Risør

Beyond Risør is the name given to a series of biennial design conferences held in Risør, Norway that always go beyond something different: in 2008, Beyond Furniture; in 2010, Beyond Lighting. The designers at Bleed were intrigued by this networked way of conferencing and in the "mindless diagrams" depicted in the book *Picturing and Poeting* by the designer Alan Fletcher (of Pentagram fame). The essential concept for the design conferences in Risør, Norway, was finally expressed in *Gravur Condensed* and with colored lines that break out in many directions and burst onto the plane in volumes. The result is a logo and an ingeniously versatile identity, capable of mutating with the theme of each year.

Bleed

Bleed is a multi-disciplinary design consultancy based in Oslo, Norway, working to challenge today's conventions around art, visual language, media, and identity.

www.bleed.no

What is your personal design process?
Most times, I do this:
- Talk to the client and think about the project.
- Find benefits, visual parallels, stories.
- Research.
- Font research.
- Try out a lot of fonts.
- Draw some by hand.
- Take a break.
- Compare everything and choose the best.
- Start to really work on it.

Where did you draw inspiration from for this project?
Alan Fletchers's nonsense diagrams influenced my work on this project. I also listened to Crystal Castles repeatedly—you can always see what music someone has been listening to while making a design. Also, my client wanted to have something happy and fun, and we accidentally mentioned a special "confetti feeling" when you are happy. I think I took the confetti too literally, but it matched the idea of "visual noise" very well.

What lessons have you learned about logo design or what do you wish you had known?
I learned that a logo has to be tested over and over again. And I also learned not to doubt my logo once I have, finally, decided on it. A logo has to be flexible enough for all media you can think of. But I also learned not to take everything too seriously. If you know the rules, you can break them.

beyond
◗ risør 2008

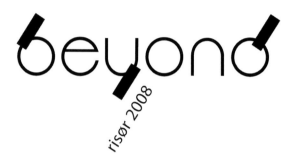

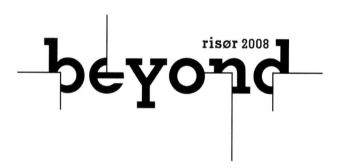

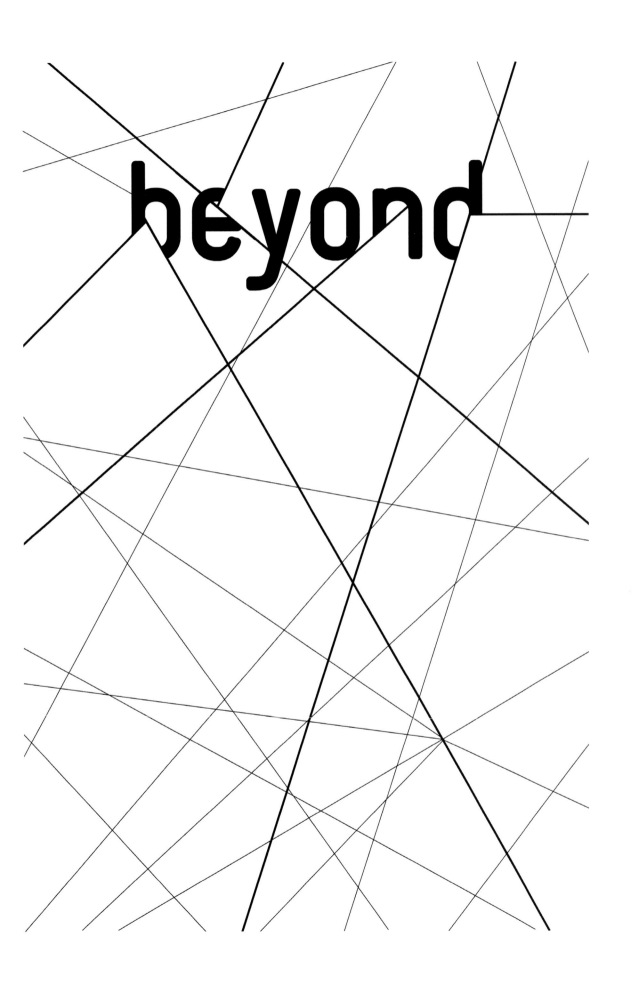

beyond

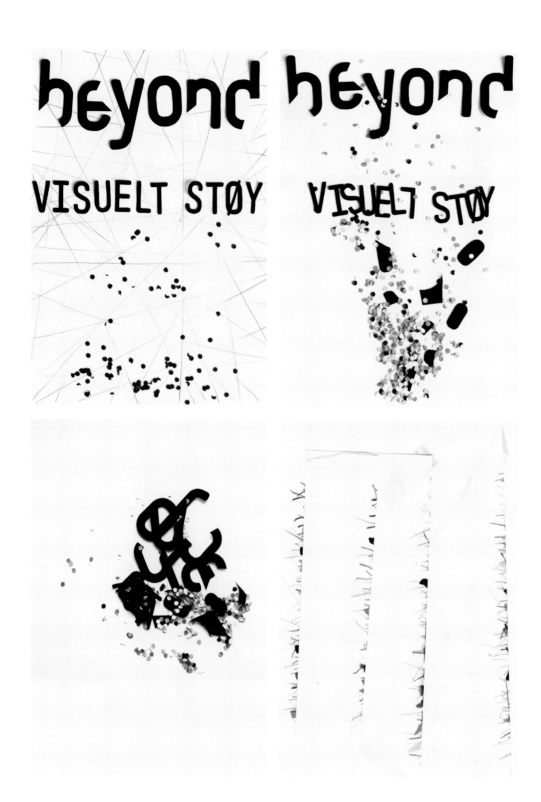

The key of this project is the word "beyond." Beyond Risør is
the name of the conference, and each edition is "beyond"
something—Beyond Acoustics, Beyond Light, etc. In 2008,
Bleed experimented manually with cutout letters, colored
balls, scanned patterns, and lines all mixed up to suggest an
out-of-control network . . . giving a noisy but positive "confetti
feeling." The logo emphasizes the networking idea that stands
behind the event.

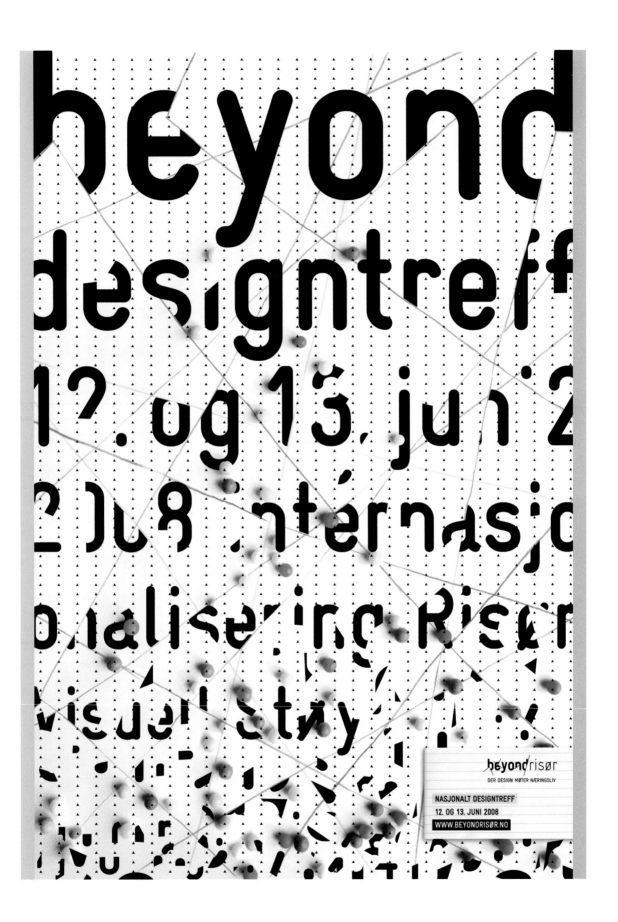

beyond
designtreff
12. og 13. juni
2008 internasjo
onalisering Risør
visuel utry

beyond risør
DER DESIGN MØTER NÆRINGSLIV

NASJONALT DESIGNTREFF
12. OG 13. JUNI 2008
WWW.BEYONDRISØR.NO

Business to Arts
Developing Creative
Partnerships

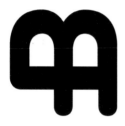

Business to Arts

Business to Arts is an organization based in Dublin that
facilitates creative partnerships between artists and the
business world. Its logo is a design by Brighten the Corners, the
studio based in London and Stuttgart whose name pays tribute
to an album of the same name by pioneering U.S. indie-rock
band Pavement. In the logo, an *A* and a *B* intertwined in black
constitute a typographical symbol that expresses the idea of
collaboration within an economy of resources. It is a staunch
symbol that maintains an off-kilter edge which easily plays
in the art world while still able to speak to the strength and
directness needed to be successful in the business sector.

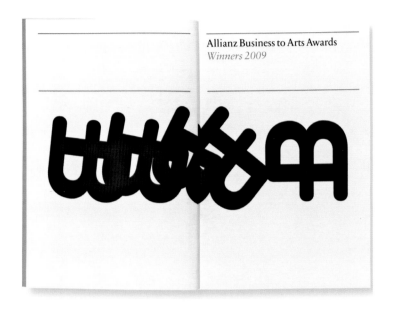

Allianz Business to Arts Awards
Winners 2009

Brighten the Corners

Brighten the Corners is an independent, multi-disciplined design and strategy consultancy firm with offices in London and Stuttgart.

www.brightenthecorners.com

What are the basic rules of logo design?
Our rules about logo design are:
- Keep it simple.
- Make sure it's shrinkable.
- Don't look at logo books.
- Don't try to reinvent the wheel.
- Don't use Rotis.

Where did you draw inspiration from for this project?
For this project we were inspired by ligatures.

What lessons have you learned about logo design or what do you wish you had known?
We have learned that the hard work in logo design begins at the end. It is then that you create an EPS_CMYK version, an EPS_Spot, EPS_BW, TIFF_CMYK, TIFF_SPOT, TIFF_BW, a JPG_CMYK, JPG_RGB, a negative version of all of the above, and a smaller version of most of the above, after which you keep all the files handy so that you can send the right one to your clients when they call.

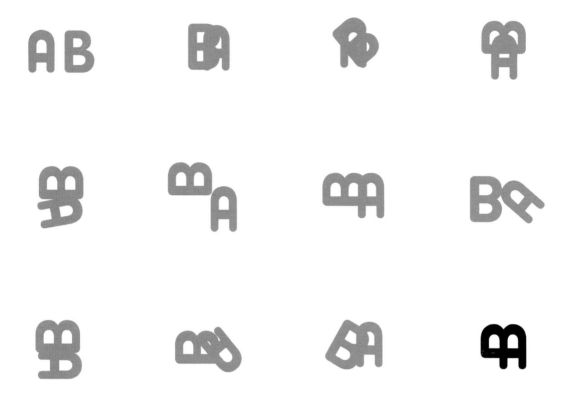

As a graphic motif on posters and brochures, the dance of the letters *A* and *B* illustrates the possibility of a vibrant pas de deux between art and business. The designers mention they were interested in the history of typographic ligatures for this logo and the notion of one character's line finishing another's is the perfect metaphor for Business to Arts' interest in the commingling of artistic and business interests. While Brighten the Corners played with a multitude of ways in which these two figures—*A* and *B*—might come together, they and their client ultimately settled on an original ligature that was at once boldly straightforward and slyly misdirecting.

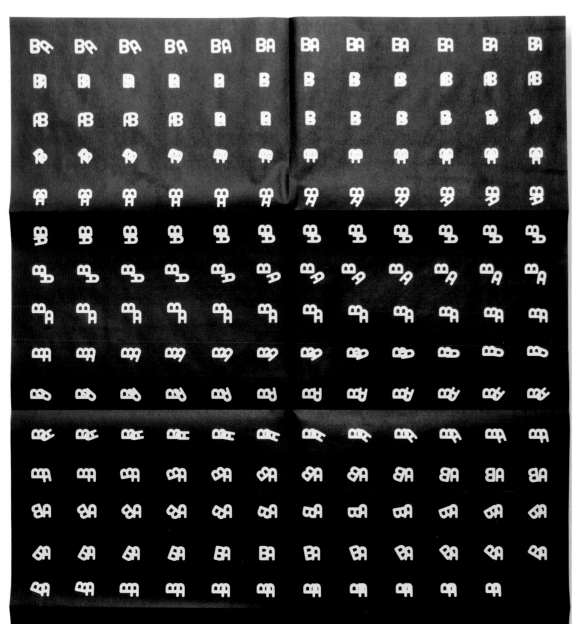

Call for Nominations

Our Sponsors

2008 will be the seventh year
of our relationship with our
sponsors, Allianz, a leading
provider of personal and
commercial insurance in Ireland.
Their generous support allows
us to create a celebration that
has become synonymous with
innovation and fun.

For the 17th year in succession
Dublin Airport Authority
have commissioned the sculptures
for the awards and, in addition,
the Authority kindly donate
the cash prize for the winning
arts organisation. For the first
time this year, we welcome
two new awards, in memory of
our good friend and former
Chair Jim McNaughton.

Tilestyle and the McNaughton
Family are sponsoring
two awards that celebrate the
commissioning process.

Closing Date

Eight copies of the Nomination
Form, Nomination Presentation
and arts support material
must reach Business to Arts
at the address below by 5pm
on Friday 28 March 2008.

Address for Entries

Awards Administration
Business to Arts
44 East Essex Street
Temple Bar
Dublin 2

T: 01-672 5336 F: 01-672 5373
info@businesstoarts.ie

Additional entry forms
can be downloaded from
www.businesstoarts.ie

Celebrating Creative Partnership

For 20 years we've been developing creative partnerships between
business and the arts and with these awards we seek out and tell the
stories behind the year's most important collaborations.

We want to hear from artists, businesses and arts organisations big and
small who have come together to create something special.
As well as celebrating business sponsorship of the arts we want to
show the whole range of collaborations and also find out more about
the individuals that are making this happen.

Unfold this poster for full details of how it works, and please join us
in recognition and celebration of your creative partnerships.

Allianz (ii)
Business to Arts
Awards 2008

Casa da Música

The initial intention was to develop an identity for Casa da Música in Porto, Portugal, without referring to its iconic building designed by Rem Koolhaas, but in the end this was virtually impossible. By researching the building's peculiar structure and its privileged position in its city, the New York-based designer Sagmeister realized that the building was an unavoidable presence. However, he and the client did not want to casually address the building in terms of a logo. So they designed a system of complimentary pieces that change in volume, while retaining the recognisable shape and structure of the edifice, transforming depending on the application and the media used. The building, in its full physical dimension, is the fixed mark in an unlimited deployment of chameleonic logos—its many graphic doppelgängers.

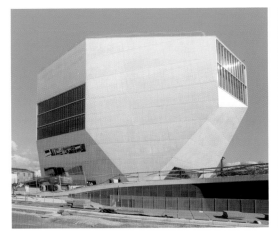
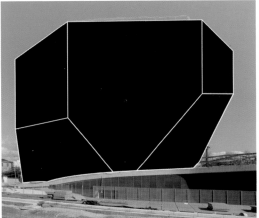

Sagmeister

Austria-born Stefan Sagmeister is a New York-based graphic designer and typographer.

www.sagmeister.com

What are the basic rules of logo design?
The basic rule of logo design is to make something that delights and works for the clients' needs. The business, applications, and audience always change, and with that the rules for the logo change.

What is your personal design process?
We first come up with a good idea. This brainstorming is generally done by using de Bono's system of random word association, and working on it coupled with periods of intentionally NOT thinking about the problem. We rarely take on projects that do not have a healthy amount of time alloted for the design process. We always get started right away to allow maximum time for ideas to be developed and then pushed and pushed and pushed.

What advice do you have for other designers?
Be nice. Work your ass off.

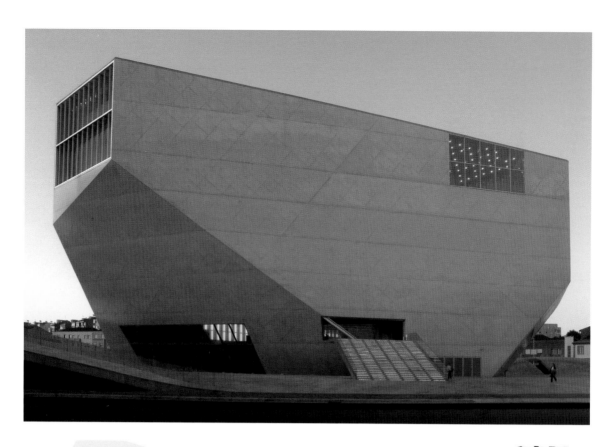

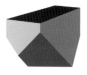 casa da música

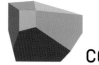 casa da música

 casa da música

 casa da música

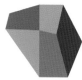 casa da música

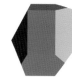 casa da música

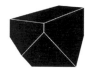 casa da música

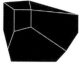 casa da música

 casa da música

 casa da música

 casa da música

 casa da música

In Sagmeister's schema, there are nearly two-dozen possible views of the building. A simple application provides color palettes as a reference image. The versatile icon communicates and grounds the somewhat eccentric fantasy of music made manifest by Koohaas' structure. The typography and detailed notions of composition match perfectly.

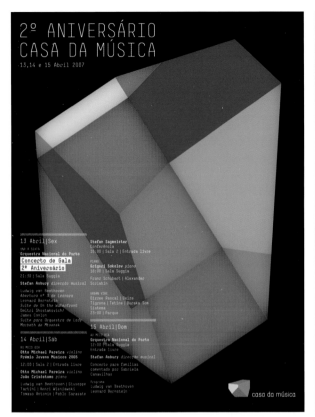

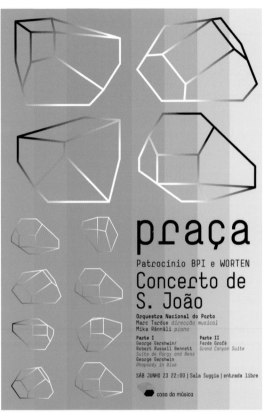

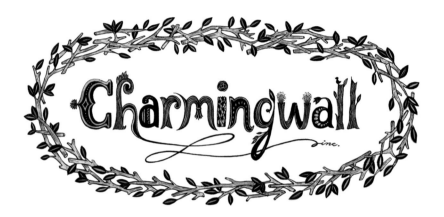

Charmingwall

The artists represented by Charmingwall, a gallery in New York's West Village, share a great ability to create images filled with whimsy and fantasy, hence the name Charmingwall and the choice of a graphic artist such as Gina Triplett for a lively visual brand that is used on the web, stationery, and signage. Triplett's illustrated logotype is a melange of textures that evoke woodgrain, patterns suggestive of embroidery, and colors that give the whole piece an old-timey charm.

Gina Triplett

Gina is an artist and designer living in Philadelphia, Pennsylvania.

www.ginaandmatt.com

What are the basic rules of logo design?
Research is key to my work, because compared to other designer's logos, mine are very image heavy. The different images need to play off each other in an intricate way. They need to add up to the concise identity of the company I'm creating them for, and not detract from one another. This can mean visual research, but really it's more about image association. I play a game in which I connect each element to all its possible references, see where these lead, and observe how they can play off of each other.

What is your personal design process?
I think of myself as more a signwriter craftsman than a logo designer. I suppose the simplicity of the traditional logo might lead one to some sort of conceptual system of reduction. That's not really how I work. I treat this type of project in the same was as any other. I figure out the mood, let my mind run around with the imagery, and feel my way through intuitively.

What lessons have you learned about logo design or what do you wish you had known?
If someone calls me for a logo or identity project, they are looking for something outside the norm. As I work, I need to trust that the big stylistic decisions were made when they chose to contact me. This leaves me free to create something that both serves the project, and stays true to my artistic sensibility.

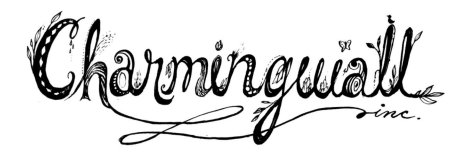

Triplett, familiar with the work of the artists shown at
Charmingwall, knew that the gallery's logo needed to express
its personality, while being an interesting piece of art in its own
right. Her answer was to illustrate the name in a style that was
at once familiar and mysterious, calling to mind both the folksy
charm of grandma's living room, and the secrets hidden in the
darkened forest behind her house. Triplett tried a number of
variations before finishing off her design with the oval frame
of garland.

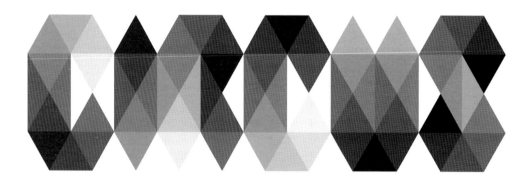

Circus

Circus is a club and restaurant in London's popular Covent Garden. Clearly, the club's owners were interested in the myth of the circus and its place in popular culture—a place where anything is possible. Inside the club, mirrors line the walls and the designers of Mind Design used this striking visual as a starting place, but went further by styling their new typographic logo as the inside of a kaleidoscope.

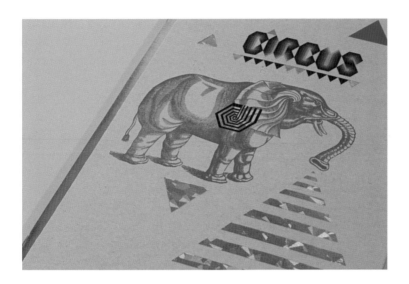

Mind Design

Mind Design is an independent-graphic design studio founded in 1999 by RCA graduate Holger Jacobs. Mind Design focuses on integrated design which combines corporate identity, print, web, and interior design.

www.minddesign.co.uk

What is your personal design process?
Sketches, lots of sketches. It is important to scribble by hand before moving on to the computer. In the next stages, we refine the logo and design additional graphic elements.

Where did you draw inspiration from for this project?
Circus is inspired by Art Deco elements. It is a restaurant featuring burlesque performances. Revue theaters were very popular during the swinging 1920s. Another influence was the steps that lead up to the main table in the restaurant, which also functions as a stage.

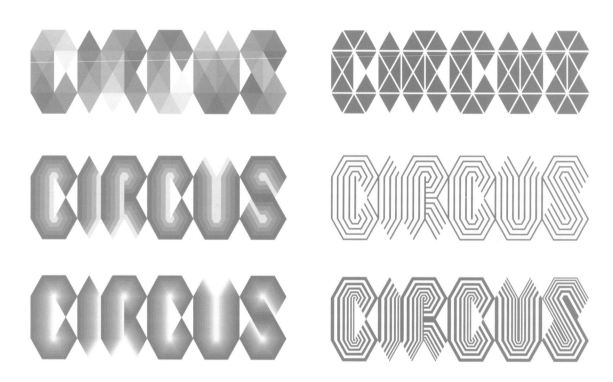

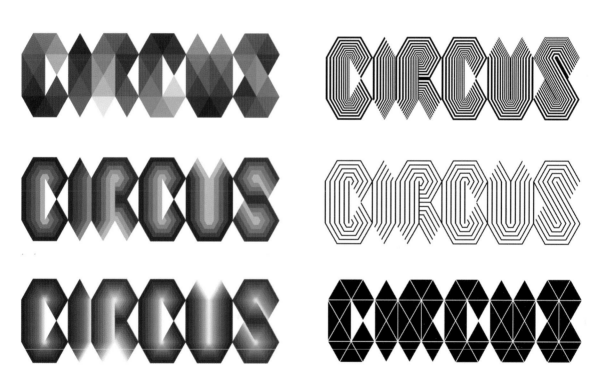

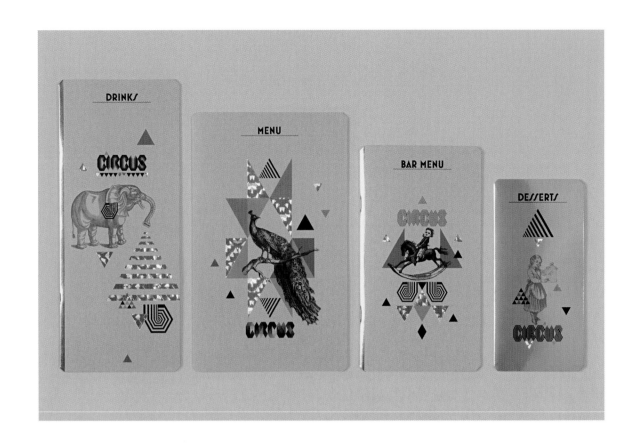

In the creation of Circus' logo, Mind Design was interested immediately in something that was geometric, versatile, and modern, while containing remnants of the past. The triangles that comprise the letters of the new typeface are arranged on a gridded system that reads as very contemporary even as the sharp grays and blacks register as a nod to bygone years.

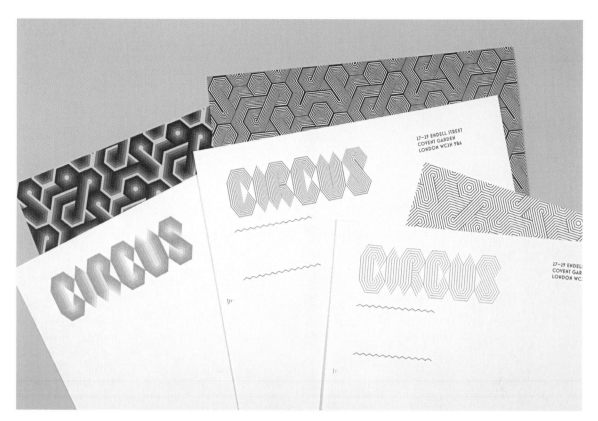

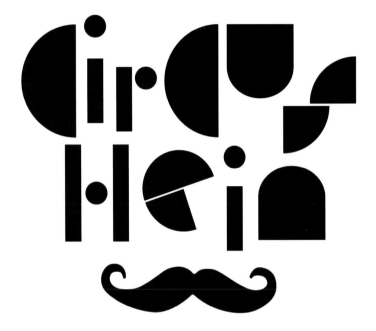

Circus Hein

Circus Hein is the title of a collaborative project led by Danish artist Jeppe Hein, created in homage to the sculptor Alexander Calder's circus projects of the 1920s. In response, Copenhagen-based designers All The Way To Paris created a dynamic logo that plays off of Calder's well-known "mobile sculptures." In ATWTP's version, the letters of the logo seem to be given dimensionality and weight even in two dimensions. The letters float over an outsized handlebar mustache, which can only reference the circus ring master, but here seems a stand in for both Hein and Calder and, perhaps, the historical continuum of modern art (and circus' privileged place within it).

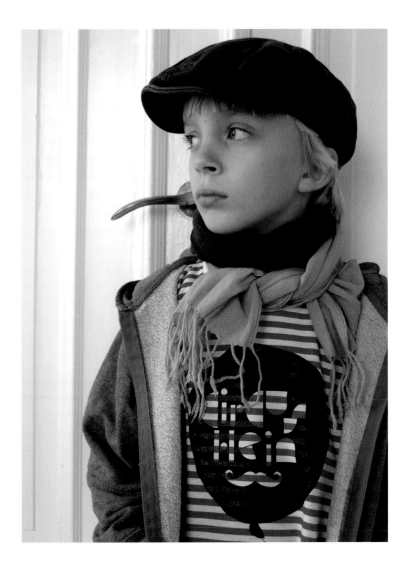

ATWTP

ATWTP (All The Way To Paris) is a graphic design studio based in Copenhagen, Denmark.

www.allthewaytoparis.com

What are the basic rules of logo design?
Get to know the brand or person or institution that you design for, and communicate the essence of their activities in a refined way.

What is your personal design process?
1. Getting the background—the in-depth interview.
2. Research, brainstorm, sketch, sketch, do new sketches, do more sketches, go back to some of the first sketches.
3. Talk with the client and finalize the design based on this discussion.

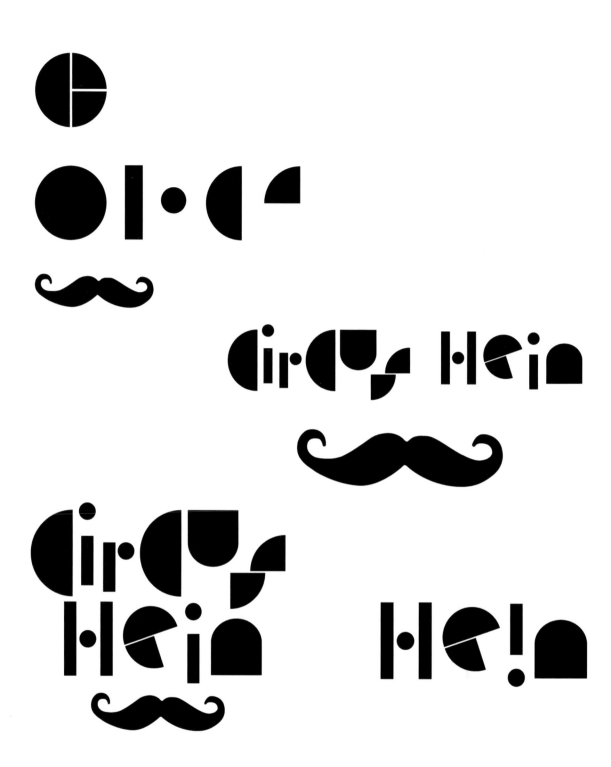

During ATWTP's process, the almost purely visual idea of a mustache uniting with letters to create a face that recalls elements of dada, gave way to a constructed typography that could be read letter by letter, and still retained much of the original's strange cut and paste Surrealism.

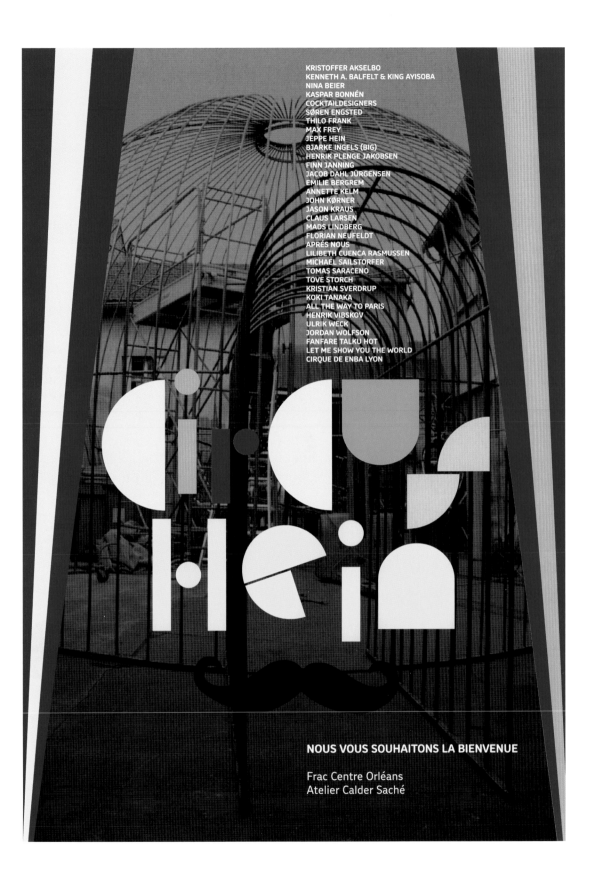

KRISTOFFER AKSELBO
KENNETH A. BALFELT & KING AYISOBA
NINA BEIER
KASPAR BONNÉN
COCKTAILDESIGNERS
SØREN ENGSTED
THILO FRANK
MAX FREY
JEPPE HEIN
BJARKE INGELS (BIG)
HENRIK PLENGE JAKOBSEN
FINN JANNING
JACOB DAHL JÜRGENSEN
EMILIE BERGREM
ANNETTE KELM
JOHN KØRNER
JASON KRAUS
CLAUS LARSEN
MADS LINDBERG
FLORIAN NEUFELDT
APRÉS NOUS
LILIBETH CUENCA RASMUSSEN
MICHAEL SAILSTORFER
TOMAS SARACENO
TOVE STORCH
KRISTIAN SVERDRUP
KOKI TANAKA
ALL THE WAY TO PARIS
HENRIK VIBSKOV
ULRIK WECK
JORDAN WOLFSON
FANFARE TALKU HOT
LET ME SHOW YOU THE WORLD
CIRQUE DE ENBA LYON

NOUS VOUS SOUHAITONS LA BIENVENUE

Frac Centre Orléans
Atelier Calder Saché

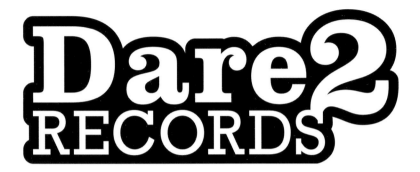

Dare 2 Records

For the logo of this new jazz-oriented label Dare 2 Records,
the Swiss designer Niklaus Troxler began by listening to music.
The client asked for a logo that would support their work
and musical ethos in much the same way a walking baseline
supports the melody. Early in his process, Troxler hit on utilizing
the numeral 2 as a way to immediately punch up the logotype
and draw the eye. In pairing the mix of letters and one solitary
numeral with a serif font of sweeping curves, he created a logo
that is every bit as expressive visually as Dare 2 Records' music
is aurally.

Niklaus Troxler
Graphic Design

Niklaus Troxler is a Swiss graphic designer currently based in Stuttgart, Germany.

www.troxlerart.ch

What are the basic rules of logo design?
First I have a serious discussion with the client to get enough information about the company and the problem that we need to solve. Then I think about that client's specific field and the media in which the logo has to be placed. Then I sketch in that specific content. The content is what is most important to me.

What is your personal design process?
The first step is contact with the client; I need a clear explanation and definition of the problem. The second step is research; I look to similar solutions in the same client fields. I want to solve my design problem differently than existing solutions. The third step is the process to finding an idea; sketching, writing down stupid and serious ideas, checking out the good ones, continuing sketching, sketching, sketching . . . and finally executing one solution for presentation to the client. (I always present just ONE solution to the client!)

What lessons have you learned about logo design or what do you wish you had known?
Make it clear, make it different, make it understandable, make it surprising.

DARE2 RECORDS

DARE2 RECORDS

DARE2

DARE2
RECORDS

DARE2

DARE2
RECORDS

Troxler's first decision was graphic, and consisted of adopting the numeral 2 in order to add visual impact and off-set what might have been a letter-heavy logo. From there, he explored a wide variety of typefaces and layouts, attempting to discover the best way to communicate his client's passion for their music. In the final logo, the harsh black and white are contrasted with the flexibility of the curved shapes, but both elements team up to transmit a sort of musical vibration.

Depeche Mode's *Sounds of the Universe*

Karlssonwilker arrived at the unique figure of a rainbow-colored rocket that shoots bubbles by remixing the elements of Anton Corbijn's design for the cover of British electronic band Depeche Mode's 2009 album *Sounds of the Universe*. Karlssonwilker's logo was to be used for the band's subsequent tour, dubbed the Tour of the Universe, which gave rise to the designer's space travel-themed reinterpretation. Corbijn's original shows colored lines jaggedly bisecting a white ring and are repurposed by Karlssonwilker as the lines that create their central image. But here, they appear in gradients, and the once dominant ring is reduced in size, but multiplied to become the bubbles. The design also appeared in the special edition packaging, along with the work of fourteen other designers, all of whom worked from Corbijn's design.

Karlssonwilker

Karlssonwilker is a New York City-based graphic design company.

www.karlssonwilker.com

What are the basic rules of logo design?
Our rules in logo design are SSBW: Smart, simple, make it work in black and white.

What is your personal design process?
Our ideas most likely happen by starting with extensive research and strategy. As soon as we have found our grid, we start playing within these rules that we have set before.

Where did you draw inspiration from for this project?
Since we were asked to remix an existing logo, we most likely ended up playing within the rules someone already set for us, and combining them with the energy we thought might fit the band. After much exploration, there it was, a rocket, which basically resulted from research and trial and error. Although, one could say the band was clearly our inspiration.

Karlssonwilker's designers confessed that, before they landed on the rocket, they could not resist trying all kinds of ideas, some a little on the crazy side. This frenetic display of creativity, though, eventually shaped up in a logo that extended Corbijn's original idea rather than eclipsing it.

DESIGN (RE)INVENTS

Design (Re)Invents

A paper clip was the ubiquitous graphical element for the 2010 Gain, AIGA Design and Business Conference. It was an inspired proposal from the Design Army studio, based in Washington DC. Simple, functional, and never out-of-fashion, the paper clip is a humble force in the everyday operations of the fields of design, invention, and business. Using paper clips as a visual element, Design Army devised an original font that they used to write the theme of the conference, "Design (Re)Invents," which referred to the ability of design to change the course of businesses, economies, and even lives.

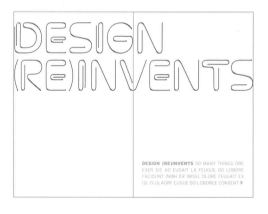

Design Army

Design Army is a Washington, D.C. top creative agency with an award-winning portfolio and a high-profile clientele.

www.designarmy.com

What are the basic rules of logo design?
A great logo has to: 1) work in all sizes and in black and white; 2) pass the "T-shirt test"—could I put it on a T-shirt and would people wear it?; 3) have a memorable concept.

What is your personal design process?
We start with a strategy and a sketch. Upon internal reviews, we narrow down to the best directions and at this point often share with the client so we can make a selection on what design to explore further. Then we go to the electronic phases. It's a very open and collaborative process that our clients learn from and also enjoy.

What lessons have you learned about logo design or what do you wish you had known?
I was taught that there can only be ONE hero with your design, no matter if it is logo or layout, you have to make a decision on what will be your hero: the icon, the type, the image... Then all other elements support that message. Things I wish I would have known? I don't think we ever stop learning, so just keep doing, but do it differently!

DESI design

DESIGN N A

L
D
D

X paperclip type

DESIGN
(RE)INVENTS

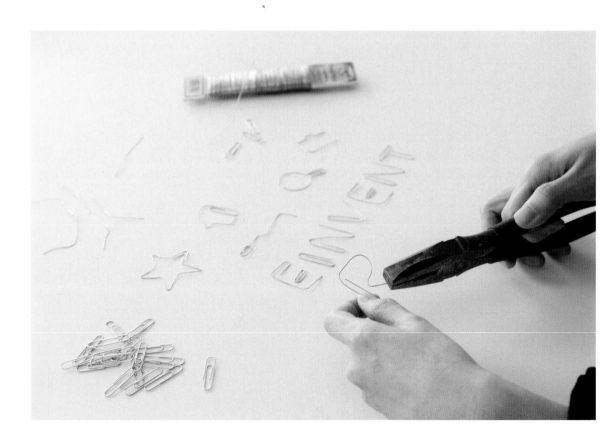

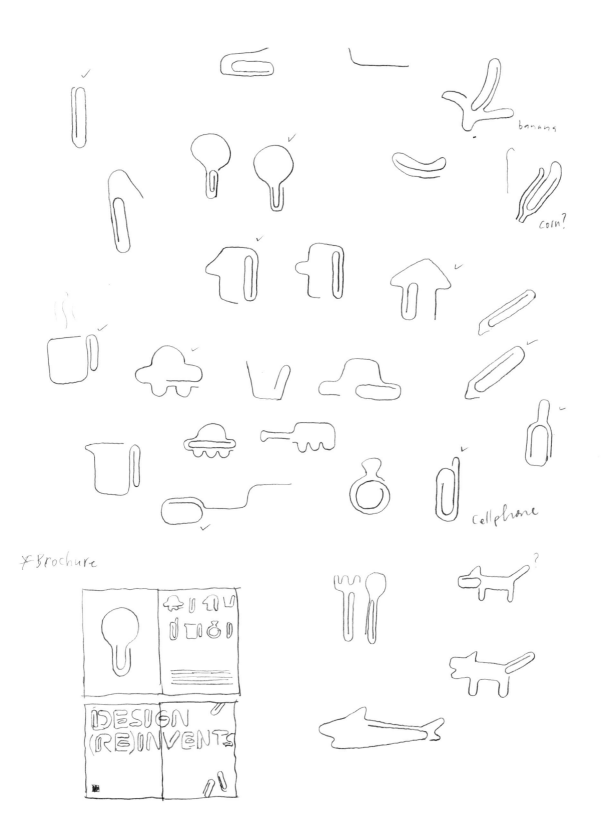

banana

corn?

cellphone

*Brochure

?

DESIGN
(RE)INVENTS

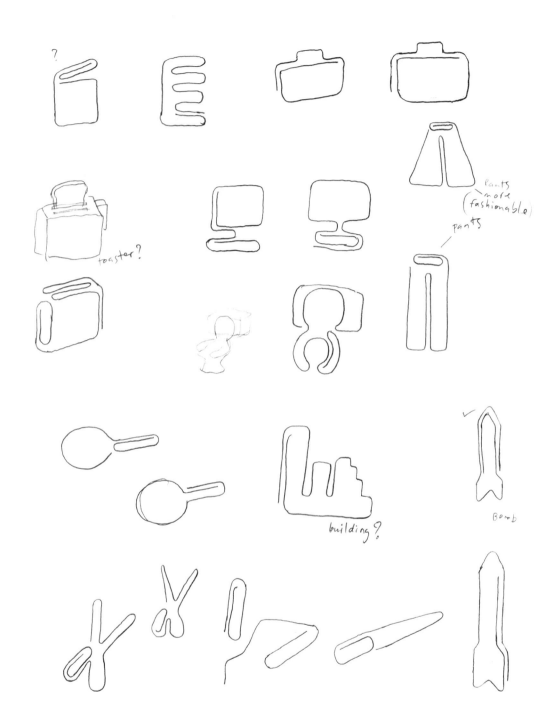

In order to create the typographic forms they had in mind, the designers had to work manually—with pliers and a lot of paper clips! Originally the idea was to work with the most basic, yet undeniably useful, elements of daily life—the toilet, scissors, a toaster—before they took a step back to something even more mundane, the paper clip, and elevated it from the prosaic to the poetic.

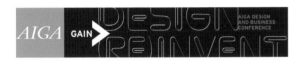

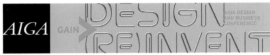

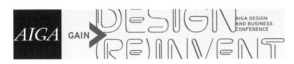

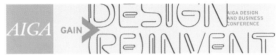

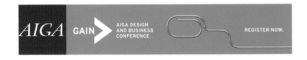

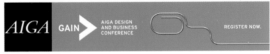

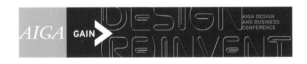

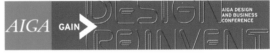

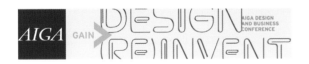

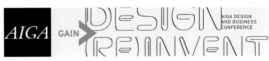

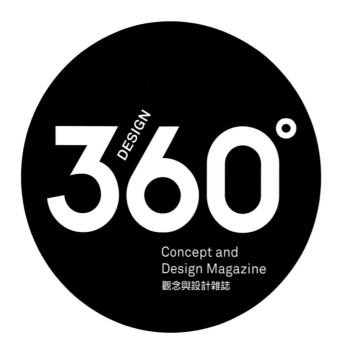

Design 360°

In the redesign of the logo and header of the journal *Design 360°*, a magazine based in Guangzhou, China, the decision to work with circles opened doors to new possibilities. First, the circle works conceptually with the idea of degrees while aiding readability. The graphic was robust enough that the name can even appear upside down without fear of violating the strength of the symbol. In addition, the emblem can be used in any color the magazine desires, and with any rotational position, giving the logo a much needed flexibility that also highlights the magazine's overarching concept.

milkxhake

Milkxhake is a Hong Kong-based design unit co-founded by
graphic designer Javin Mo and Interactive designer Wilson Tang
in 2002, focusing on graphic and interactive mixtures.

www.milkxhake.org

What are the basic rules of logo design?
Examine the brief and listen to your client carefully.
Designing a logo is not like simply designing a T-shirt.

Where did you draw inspiration from for this project?
The logo was created from the magazine name and was
inspired by the concept of "degree," it recalled the new
editorial structure resulting from different "degrees" of the
the name "360°". It was created and modified from the old
logo, but it highly enhanced the legibility of the name, with
the circle representing the degree symbol, resulting in a
strong identity for the magazine.

DESIGN 360°

01/2009

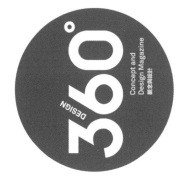

360° F

FEATURE°訪談

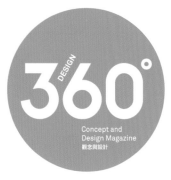

90° V

VISION°視野

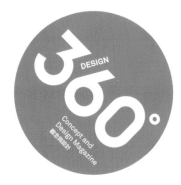

135° CC

CREATIVE CHINA°
創意中國

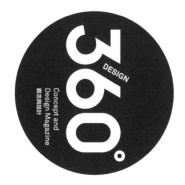

180° GD

GRAPHIC DESIGN°
平面

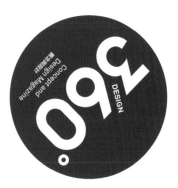

225° PD

PRODUCT DESIGN°
產品

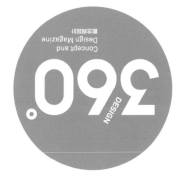

270° DE

DESIGN EXCHANGE°
設計交流

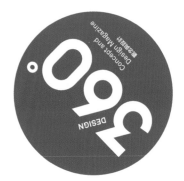

315° DH

DESIGN HAPPENINGS°
設計動態

In addition to its prominent place on every cover of the
magazine, the logo is also used for sections of the magazine:
graphic design, industrial, interior, artwork, and even new
media.

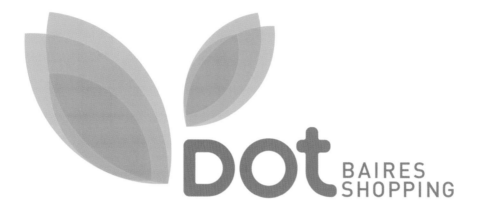

DOT Baires shopping mall

The inspiration for the logo for the DOT Baires shopping mall in
Buenos Aires emerged from its internal architectural structure.
As seen on the building's ground-plan, the large atrium
and the pergolas of the outdoor sitting area were formally
reconstructed to comprise the petals of a simplified flower.
The unique found shapes of these two areas were accurately
observed and then turned on their heads, giving rise to a symbol
that appeals to all shoppers.

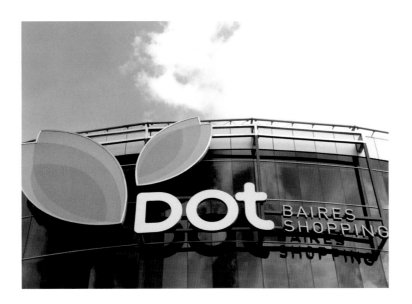

Diseño Shakespear

Lorenzo Shakespear / Juan Shakespear / Ronald Shakespear / Martina Mut / Eliana Testa / Gonzalo Strasser / María Spitaleri / Claudio Sarden / Juan Hitters / Héctor Calderone

Diseño Shakespear is a Buenos Aires–based branding, marketing, and design firm.

www.webshakespear.com.ar

Where did you draw inspiration from for this project?
In the case of DOT, the logo arose from the architectural plan, becoming an orange flower aimed at a female public.

What lessons have you learned about logo design or what do you wish you had known?
The brand is not a logo, it's a promise. In any case, the logo is the flagship of that promise. And some brands die out. A virtuous brand is one that keeps its promises, an effective brand is one that emits the correct identity, and a good brand is one that attracts attention.

The dilemma of the three *i*'s: identity, identification, and image. The first is in the soul of the transmitter; the second is the strategy to transfer that identity; the third is the fantasy that the audience elaborates from the first.

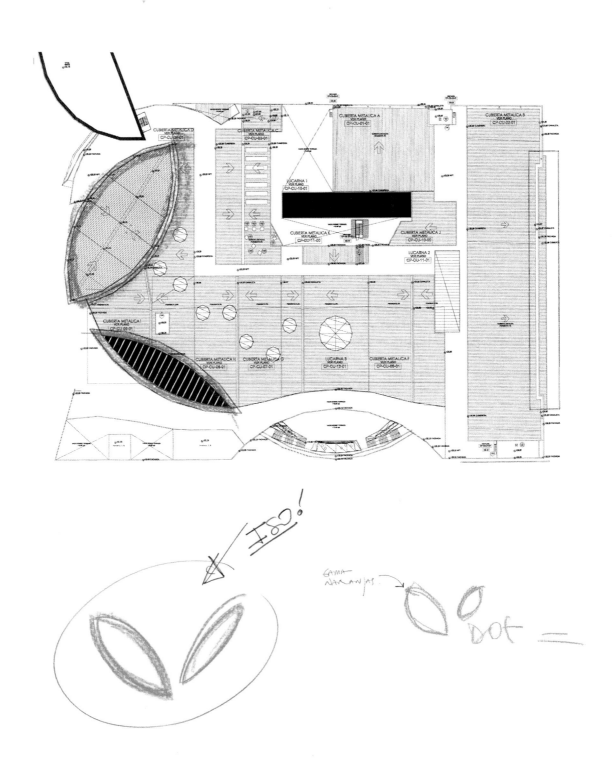

The logo's curves and soft hues of oranges and yellow create a welcoming, low-key environment that invites shoppers in. For the name, the designers at Diseño Shakespear created a new font: DOT.

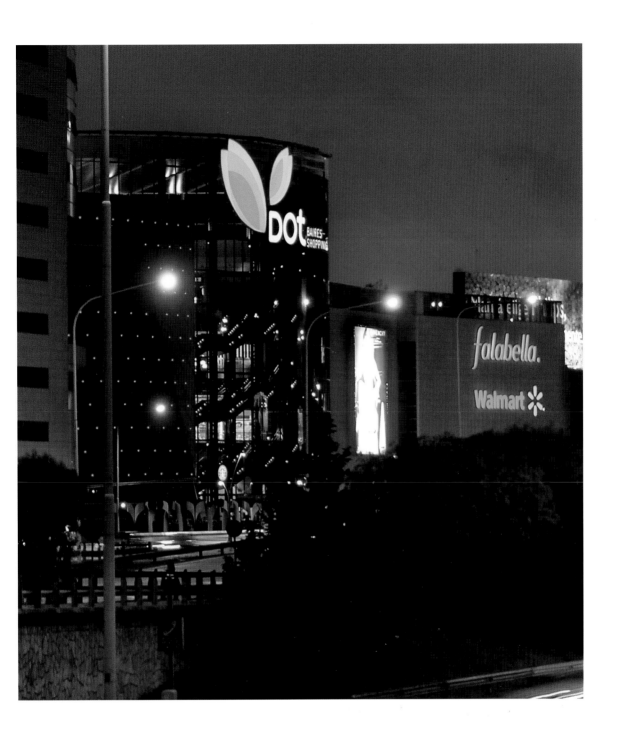

Dr. Nick Lowe

In order to break into a saturated market, brands have to
employ a visual label capable of attracting attention while
conveying self-confidence. These principles guided London's
R Design as they tackled the identity and logo for dermatologist
Dr. Nick Lowe in the launching of a new line of skin-care
products. The straight lines that encompass the name of the
company provided a framework that was both simple and
memorable. Perhaps counterintuitively, graphic inspiration
came from Bauhaus graphic designer and typographer, Herbert
Bayer, who developed his own "universal" typeface which,
unlike the script used, was all lower-case, strongly geometric
and Sans Serif.

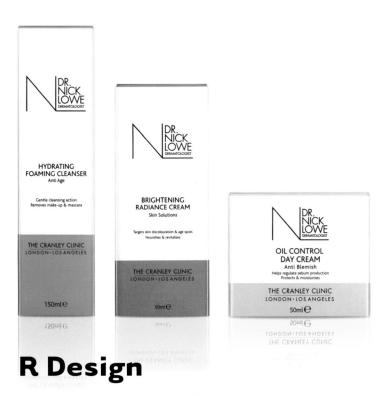

R Design

R Design is a full-service branding company based in London.

www.r-website.co.uk

Where did you draw inspiration from for this project?
We took inspiration from Herbert Bayer's cover design for a 1925 catalog of Bauhaus products.

What lessons have you learned about logo design or what do you wish you had known?
We've learned that simplicity is the key. Our approach to every job is always the same, but we must be aware of different markets and the issues those bring. It's important that our logos and identities reflect the client's personality or type of business. Without research, you can't hope to gain a proper understanding of the client and the context in which your logo will appear.

nick lowe

R Design notes that they strive for a simple, direct, communicative approach. Here, a sleek and commanding *N* full of personality is created, connecting to the *L* of Lowe which supports the company's full name and lends the entire image (and brand) a feeling of sure-handed competence.

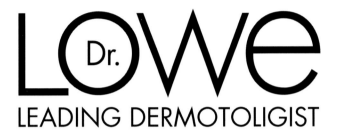

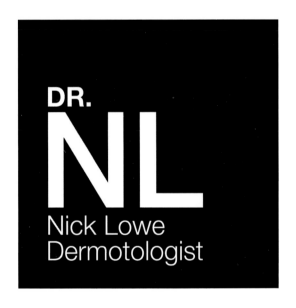

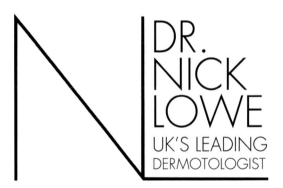

DREISPITZHALLE

Dreispitzhalle

At no stage of the logo design for the Dreispitzhalle of the Christoph Merian Foundation was paper used for the sketches. The typeface was literally born on the facade of this former warehouse that is located in the area of Dreispitz in Basel, Switzerland, and is home to a new cultural space. Several days of taking detailed measurements and trials with a projector resulted in the irregular type that today stands sixty meters tall on the building's exterior walls. However, when the logo is used on paper it is always in conjunction with the black icon of the silhouette of the building.

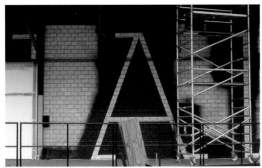 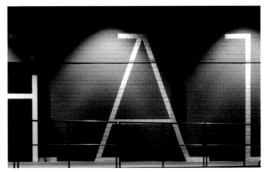

Hauser, Schwarz

Hauser, Schwarz is a young agency for visual communication
that develops graphic solutions for clients in diverse fields. The
agency is led by Simon Hauser and David Schwarz, and is based
in Basel, Switzerland.

www.hauser-schwarz.ch

What is your personal design process?
Our personal design process is normally like this:
- We begin by listening very carefully to the client's need.
- Then we develop a concept that supports it.
- Only then do we start finding an adequate visual solution.

Where did you draw inspiration from for this project?
For the Dreispitzhalle project, we were inspired by the very
functional architecture of the building and its industrial
environment. We wanted to re-create this atmosphere
throughout the visual communication.

What lessons have you learned about logo design or what do
you wish you had known?
We have learned that it's not necessary to have a logo in a
traditonal way (an icon together with typography). Actually,
no logo is necessary.

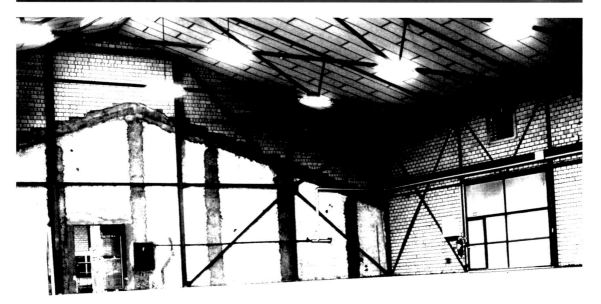

DREISPITZHALLE
TOR 13

→ EINTAUSENDFÜNFHUNDERT QUADRAT-
METER FÜR AUSSTELLUNGEN FESTIVALS,
PROJEKTE UND VERANSTALTUNGEN ←/→

A B C D E F G H I
J K L M N O P Q R
S T U V W X Y Z
$ € & / @ Æ ↑ ↓

DREISPITZHALLE

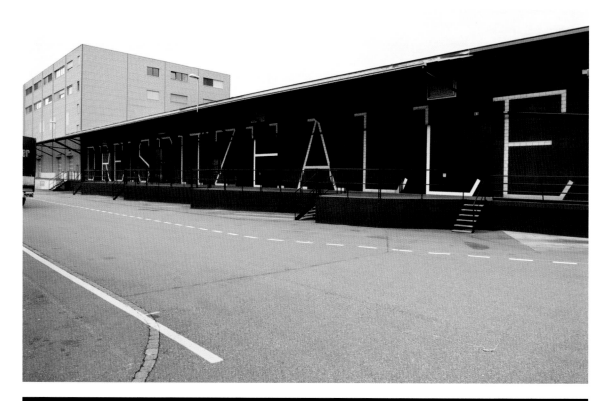

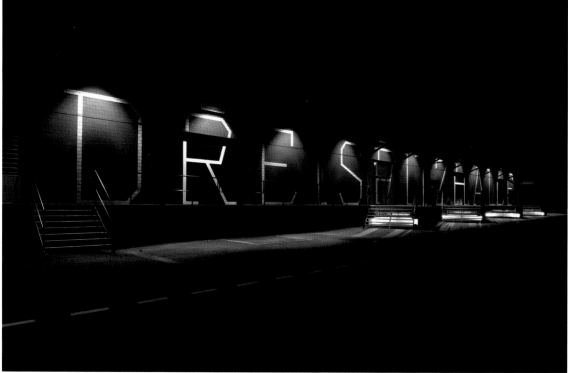

Hauser, Schwartz's work took the Dreispitzhalle's architecture as its major influence. The steel beams inside the old warehouse inspired a thin-line font with angular cuts, and slim in size. The website features an animation that shows lively silhouettes of the building from various angles morphing from one to another.

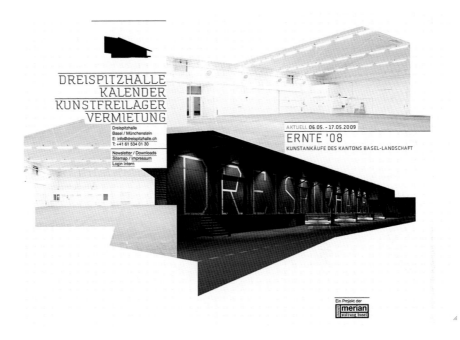

durables
ustainabldesir
ablarchitectur
edurablsouten
abldésirablar
chitecturdura
blsustainabld
esirablarchite
cture

Durable, Sustainable, Desirable Architecture

"Durable, Sustainable, Desirable Architecture" was the name
of a conference on sustainable architecture organized by the
European Forum for Architectural Policies in Bordeaux in 2008.
Mewes textual sign came from simple typographic solution
and is characterized by a lack of spaces between words, no
text indentation, and the Ɛ of each term repeating in green.
The green Ɛ may refer to "ecology" and connects the essential
terms of the projects title utilizing the universal color of the
ecological movement.

Florian Mewes

Originally from Berlin, Germany, Florian Mewes is a graphic designer living and working in Amsterdam. In 2011, he teamed up with Dutch designer Arjan Groot to form Groot/Mewes, a firm specializing in conceptually rigorous yet accessible design.

www.grootmewes.com

What is your personal design process?
Making a lot of sketches is the most important part. Going in and out of different ideas creates yet more ideas. Often I start with writing down what I want to tell in beautiful language, which often leads to a beautiful logo.

Where did you draw inspiration from for this project?
This identity is based on an endless, durable, text pattern, which also fits the long name. From this pattern, I'm able to develop one logo—since we sometimes need them—like a moment in time or a movie still. Very simple typographical solutions are still one of the best ways to bring things to a point—so we all know what it's about.

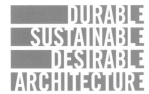 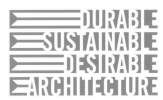 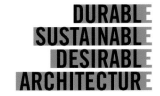

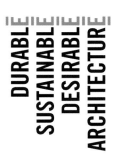 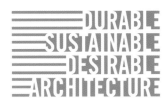 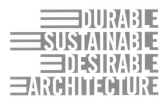

In the final version, the repeated phrase gains graphic strength even as the meaning of the words, separately and together, come to the readers' attention. Rather than simply the repeated Ɛ of earlier versions, an idea that remained purely visual, the end result is like a slow moving, but powerful wave that washes over the viewer, assailing him or her on multiple levels. Rendered in Avant Garde, the logo flirts with unreadability, making the viewer work just a little to come to comprehension (and to discover the designer's playful use of multiple languages.)

DURABLE 9&10
SUSTAINABLE OCT 2008
DESIRABLE BORDEAUX,
ARCHITECTURE FRANCE

DURABLE 9+10 OCT'08
SUSTAINABLE SUBTITLE SUBTITLE
ARCHITECTURE IN THE AGE
OF POST-PRODUCTION
DESIRABLE BORDEAUX,
ARCHITECTURE FRANCE

DURABLE ARCHITECTURE
IN THE AGE OF
POST-PRODUCTION
SUSTAINABLE LECTURES,
DEBATES,
WORKSHOPS
DESIRABLE 9&10 OCT 2008
BORDEAUX,
FRANCE

DURABLE ARCHITECTURE
IN THE AGE OF
POST-PRODUCTION
SUSTAINABLE LECTURES,
DEBATES,
WORKSHOPS
DESIRABLE 9+10 OCT 2008
BORDEAUX,
FRANCE

durable
sustainable
desirable
architecture

durable
sustainable
desirable
architecture

durablesus
tainabledesir
ablearchitec
ture

durabl
esustainabl
edesirabl
earchitecture

durablesus
tainabledesir
ablearchitec
ture

durablsus
tainabledesir
ablearchitec
ture

durablsustainabldesirabl arch
itecturdurablsustainabldesira
blarchitecturdurablsustainabl
desirablarchitecturdurablsus
tainabldesirablarchitecturdur
ablsustainabldesirablarchitec
turdurablsustainabldesirablar

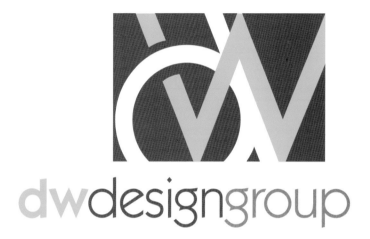

DW Design Group

In beginning a new logo design, the Fort Collins, Colorado Company Toolbox Creative stresses listening to the client and asking questions. The idea of working from different combinations of *D* and *W*, the client's initials, came from Dion Williams, owner of the interior design company DW Design Group. The designers then set about trying out a vast, often starkly contrasting, array of strategies that incorporated that germinal idea. The finished logo features a well-balanced interplay between the two letters that also creates new, surprising spaces much like a particularly well-designed room makes space for its inhabitants.

Toolbox Creative

Toolbox Creative is a full-service design firm specializing in branding, based in Fort Collins, Colorado.

www.toolboxcreative.com

What are the basic rules of logo design?
Understand the brand. We do that by asking questions, listening, researching, and writing a creative platform that will be the foundation of the brand design. It is critical that we know the client's audience, mission, attitude, and goals before we put pencil to paper.

What is your personal design process?
Process is critical. Our first step is to conduct a marketing "mind jam." At this creative brainstorming session, our team meets with the decision maker and the key influencers related to the client. This is a great opportunity to hear the voice of the brand firsthand from people at various levels within and outside the organization. We take detailed notes and develop a creative platform that becomes the road map for our creative exploration. We present black-and-white logos first.

Where did you draw inspiration from for this project?
The client came to us not with sketches, but a strong vision of a lowercase d and w playing a prominent part in her identity. We toured some of the beautiful spaces she designed and drew inspiration directly from her work.

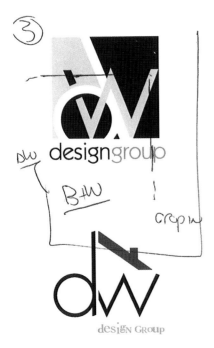

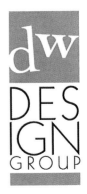

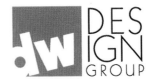

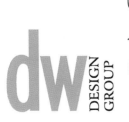

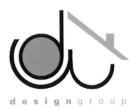

For Toolbox Creative, process is paramount and, as such, they often spin out a lot of ideas quickly which are then refined and lead to new ideas. The use of symbols suggesting buildings and architectural structures was quickly discarded because it created too many narrow limitations for as versatile a company as DW Design Group. Toolbox Creative sought inspiration directly from DW's interior designs, exploring the subtle marriage of textures, materials, and colors that are expressed through the final logo's balanced, but happily off-center logo, with its surprising stew of earth tones, a soft yellow green, and white created out of the negative space of the entire composition.

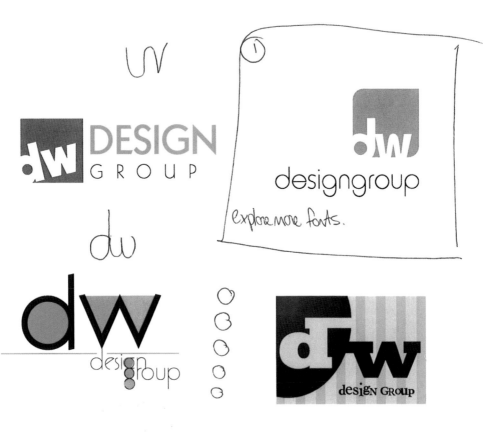

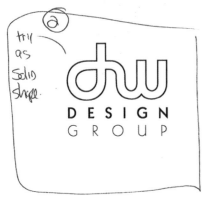

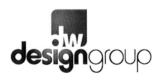

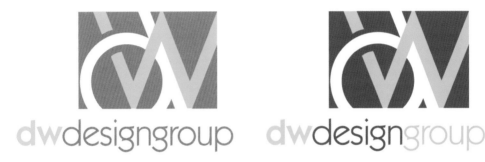

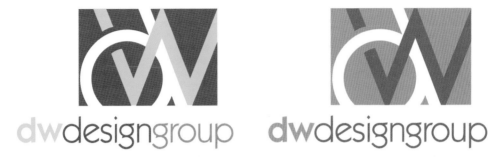

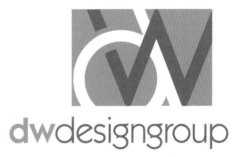

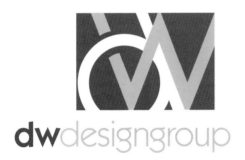

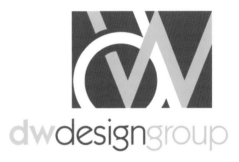

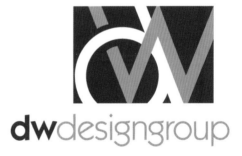

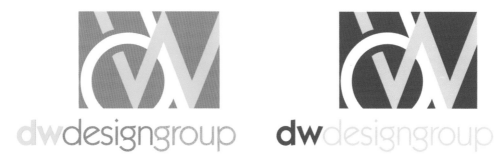

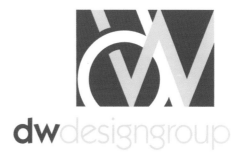

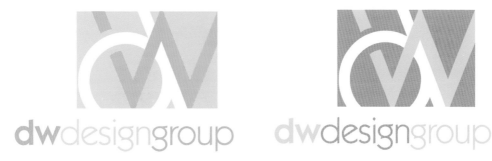

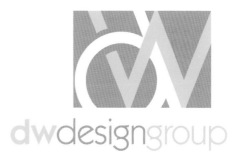

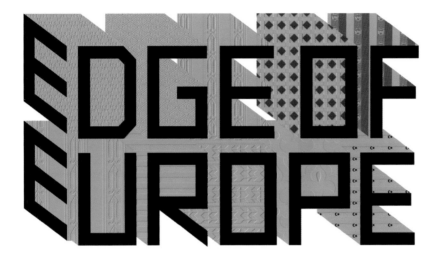

Edge of Europe

The surface of the letters spelling "Edge of Europe" are
projected volumetrically to their core, and result in a three-
dimensional prism—a strong colorful stamp with the possibility
of countless graphic motifs. The variability of this visual
system, which is almost a hallmark of Lava's designs, is applied
this time to a sports-apparel and outdoor adventure company.
Rich and attractive, the contrasting patterns present a sense
of a pan-European identity without being too heavy-handed,
lending just the right amount of gravitas to the label.

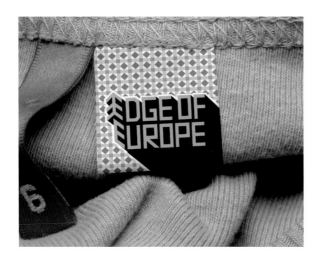

Lava

Lava is a design studio founded in 1990 in Amsterdam.

www.lava.nl

What are the basic rules of logo design?
The essence of logo design is to find the balance between consistency and change. Traditionally, logos, identities, and brands are designed to remain static. This was successful when the world was less dynamic, but in today's world, businesses use adaptive strategies. Hence logos, identities, and brands need to echo this adaptive strategy. We need to create dynamic identities that live, learn, and adapt.

What lessons have you learned about logo design or what do you wish you had known?
The key word is identity, not logo. Visual, corporate, or brand, it is the identity that runs throughout all that unifies these terms.

 A logo identity is the most basic level of an identity. A logo is a signature and should not attempt to communicate more than that. It should be clear and perhaps only hint at what the organization does—a common failure in logo design is to attempt to say too much with it.

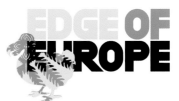

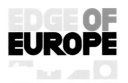
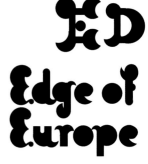

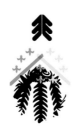

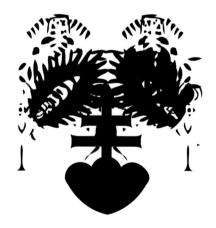

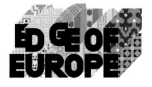

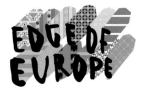

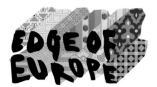

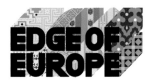

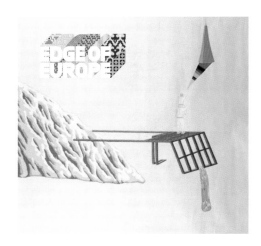

During the process, Lava's designers investigated the many
colors and visual identities of the countries of Europe
represented by their various flags and crests. They wanted
to showcase the cultural richness and variety of European
heritage, but discarded the use of flags as too didactic.
The final design allows for this interest in a subtle and
intriguing way.

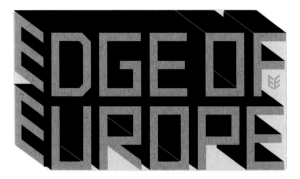

RONAN O'RIORDAN
EDGE OF EUROPE LTD.
GURTEENROE, BANTRY,
CO.CORK, IRELAND
M +31 627 433 050
F +353 27 50550
E RONAN@EDGEOFEUROPE.COM
W WWW.EDGEOFEUROPE.COM

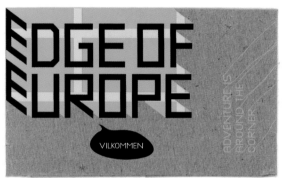

VILKOMMEN

RONAN O'RIORDAN
PRESIDENT/CEO
GURTEENROE BANTRY
CO.CORK, IRELAND

PHONE +33(0)214772736
CELL +33(0)214772736
RONAN@EDGEOFEUROPE.COM
WWW.EDGEOFEUROPE.COM

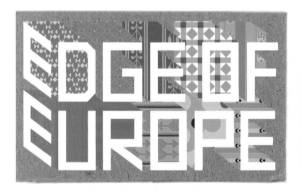

RONAN O'RIORDAN
PRESIDENT/CEO
GURTEENROE BANTRY
CO.CORK, IRELAND

PHONE +33(0)214772736
CELL +33(0)214772736
RONAN@EDGEOFEUROPE.COM
WWW.EDGEOFEUROPE.COM

RONAN O'RIORDAN
PRESIDENT

EDGE OF EUROPE
GURTEENROE, BANTRY
CO.CORK,IRELAND

T+353(0)214772737
F+353(0)214772734
WWW.EDGEOFEUROPE.COM
RONAN@EDGEOFEUROPE.COM

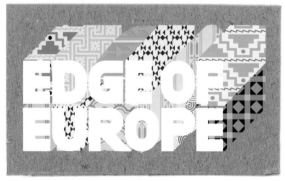

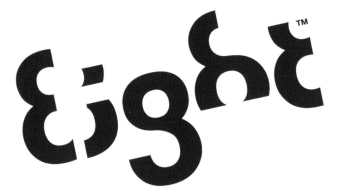

Eight

Eight is a newly created company dedicated to corporate communications, with an initial workforce of eight people. For central London's Stylo Design, the company's name immediately presents a result: Eight. The logo is resolved from a typeface of mutilated numeral eights, which rest on an ascending line to suggest the company taking off. All of this was produced by Stylo, for whom a logo is "the expression of a company's value through type and/or a marque represented in as concise a way as possible."

Stylo Design

Stylo Design is a multi-disciplinary design and digital consultancy firm based in central London.

www.stylodesign.co.uk

What is your personal design process?
A standard logo design process is as follows:
– Initial research, including client liaison, reference competitors, name generation (sometimes).
– Brainstorm and generate ideas.
– Preliminary sketches.
– Initial digital versions.
– First client meeting and client feedback.
– Secondary digital investigation.
– Second client meeting and client feedback.
– Final digital investigation, ending with production of final solution.

Where did you draw inspiration from for this project?
The solution is simply derived from the company name, which was derived from the eight founding members. Although the idea is extremely simple, just arriving at the final solution was a relatively lengthy process, culminating with a eureka moment. The execution of the final logo was fairly straightforward once the concept was in place.

What advice do you have for other designers?
You never stop learning, a tremendous cliché I know, but never truer. Keep abreast of what other designers or agencies are doing. Ensure that when you do draw inspiration from others, you do not overstep the boundaries—i.e.—you do not plagiarize their work.

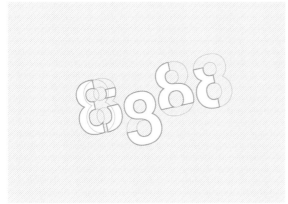

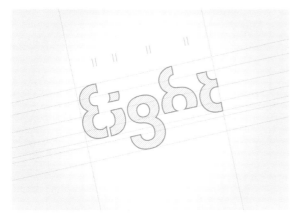

Avenir Medium

AaBbCc0123

abcdefghijklmnopqrstuvwxyz
ABCDEFGHIJKLMNOPQRSTUVWXYZ
0123456789

Avenir Black

AaBbCc0123

abcdefghijklmnopqrstuvwxyz
ABCDEFGHIJKLMNOPQRSTUVWXYZ
0123456789

As the designers suggest, the idea for this logo is quite simple:
the company's name, Eight, spelled out by chopping up
numeral eights to form the letters of the word. However, this
simplicity of concept required the designers to be rigorous in
choosing the typeface that would allow for the logo to not only
be rendered readably, but also communicate the nature of
the client's personality. Eventually, they settled on Avenir, a
fairly contemporary typeface which draws its inspiration from
the older Futura but possesses a more organic quality that
allowed for mutability as the designers manipulated numbers
to form letters.

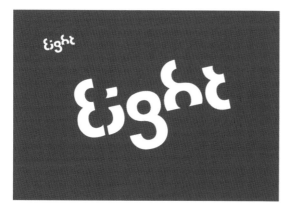

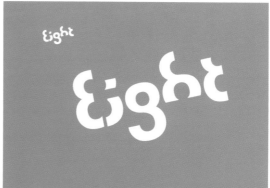

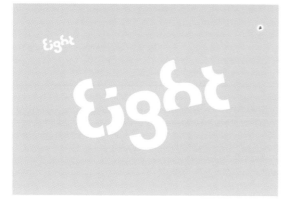

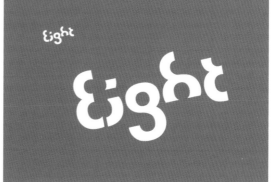

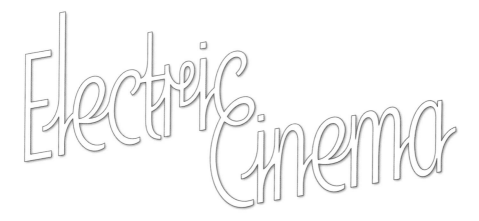

Electric Cinema

The creative brief for a new logo for Electric Cinema, the underground movie theater in Amsterdam, was simple: do whatever you want, but it must be square. However, Pinar&Viola had a different idea, and the client could see the potential for the vibrant brand in the arresting sinuosity created by the designers. Neon and disco lights, fifties drive-in cinemas, and the golden age of Hollywood are influences that stand out in the Electric Cinema brand.

Pinar&Viola

Pinar&Viola is an Amsterdam-based graphic design company comprised of Pinar Demirdag and Viola Renate, specializing in what they describe as "ecstatic surface design."

www.pinar-viola.com

What is your personal design process?
Reading the brief carefully, and doing research on the brand. Further on, contemplating the possible future associations, metaphors, emblems, and iconography around the logo. And finally, always ending with a Pinar&Viola touch, which is everything but Modernism.

Where did you draw inspiration from for this project?
The inspiration for this project for Electric Cinema came from neon light signs, disco lights, fifties drive-in cinema's, old and odd American movie theaters, and the Dynamic Ribbon Device.

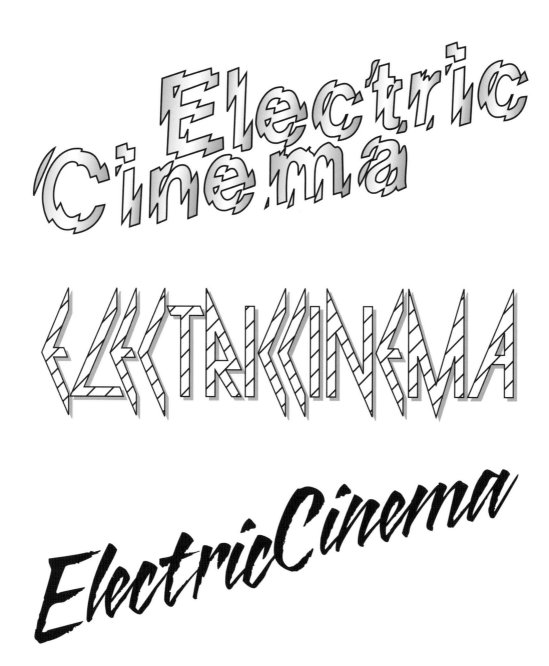

In most of the proposals, a diagonal upward sweeping angle was employed to give motion to the name. The designers tried a variety of complimentary aesthetics that suggested different neon signs, many of which were discarded because they recalled album covers from the 1980s more than something timeless. In the end the designers and the client agreed on a more classic version featuring flowing script.

Electric Cinema

Electric Cinema

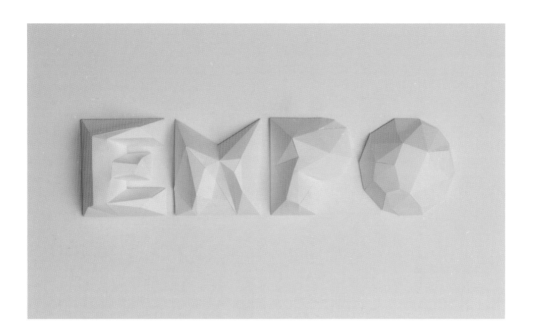

EMPO School of Organic Osteopathy

For the identity of the EMPO School of Organic Osteopathy, LoSiento began studying the human body and its parts. At first, its morphology inspired some full-volumed organs and bones with a medical school-like style, which they built in multicolored cards. Only later did they conceive and create the bone-colored alphabet, which they then photographed. Each letter is an educational and three-dimensional unit, containing insights on the human body, and presenting the skeleton as the most basic of architectural systems.

LoSiento

LoSiento is a Barcelona-based studio that specializes in 3D typography, packaging, and product design.

www.losiento.net

What are the basic rules of logo design?
-Know the product that you are going to create an identity for.
-Study the briefing in depth and discuss the details with the client.
-Process the initial ideas with the client.
-It is important to have the client at hand during the creation process so they can make it their own.

What is your personal design process?
-Define the essential characteristics of the product, person, or company in question.
-Research the values of the project, its target, receiver, or final consumer.
-Typographic study.
-Composition of the graphic identity.

Where did you draw inspiration from for this project?
EMPO is a school and psychological-osteopathy consultancy—the acronym stands for *Escuela de Motilidad y Psico-osteopatía Orgánica* (School of Organic Osteopathy). The project used the study of the human body as a starting point. To relate the parts of the identity, we studied how to create a unique alphabet for the project.

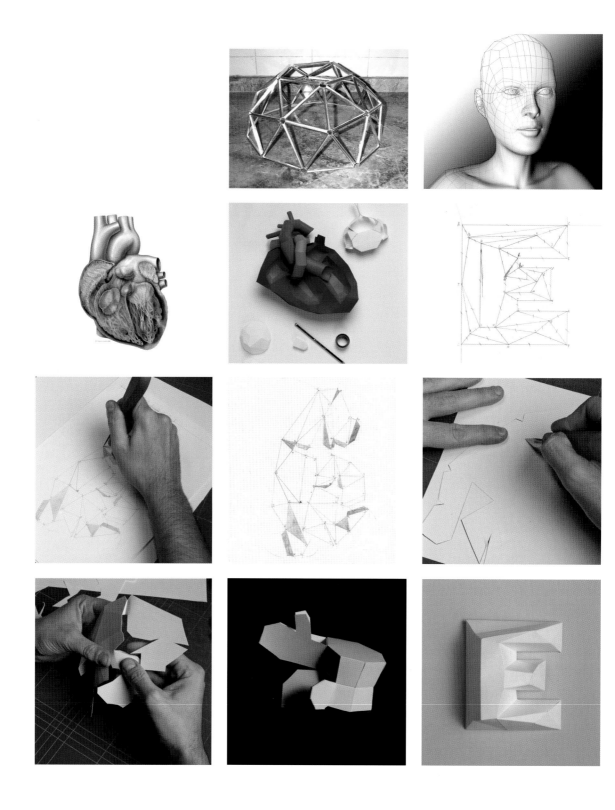

The designers utilized the Pythagorean theorem to make it easier to work with the sides and faces so that all three parts are of equal size and structure.

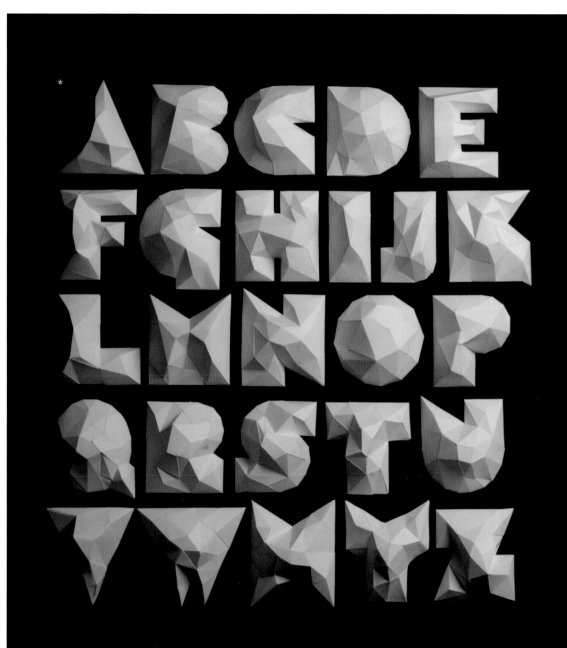

EMPO typeface

Estudio: LOSIENTO
Diseño: Gerard Miró

* Alfabeto realizado por formulación matemática
basado en la fórmula de pitágoras:

Distancia real = Raiz cuadrada de la suma de
los cuadrados de la diferencia entre coordenadas
correspondientes

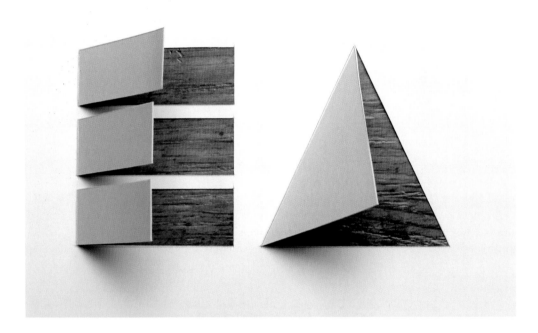

Estudi Artik

Crafts and ingenuity are trademarks of style in the execution of LoSiento projects. They love to explore three dimensions, and on this occasion, they have done so by cutting out the letters E and A, the initials of Estudi Artik, on white cardboard. For this interior design studio, LoSiento produced letters that, like doors or windows, are hinged on a stationary axis and that open onto both real and hypothetical rooms. Floral prints and marble or wood motifs line the interior surfaces and become an interchangeable element that lends the logo(s) versatility.

ESTUDI ARTIK
David Sánchez

Casanova, 234, Atico
Barcelona 08035
T 93 2056674
david@estudiartik.com
www.estudiartik.com

ESTUDI ARTIK
Mauro García

Casanova, 234, Atico
Barcelona 08035
T 93 2056674
mauro@estudiartik.com
www.estudiartik.com

LoSiento

LoSiento is a Barcelona-based studio that specializes in 3D typography, packaging, and product design.

www.losiento.net

Where did you draw inspiration from for this project?
We were inspired by the concept of interiors. The typographical windows show the interior as if it were a door or window that shows you what's inside.

What lessons have you learned about logo design or what do you wish you had known?
Basically, a logo does not have to contain all the information about what it visually represents. It is important to find a small feature or detail that really reflects the project. The most important thing for us is that it has, however small, a representation of the soul or essence of the project description, of the identity. It must have its own life and allow for different interpretations or thoughts on what it represents.

What advice do you have for other designers?
My advice is when designing a logo, you should really try hard to find an idea that strongly represents the identity of the project. To do this, it is essential to analyze and extract all relevant information that helps you create a strong argument, capable of reflecting the project in a shocking way.

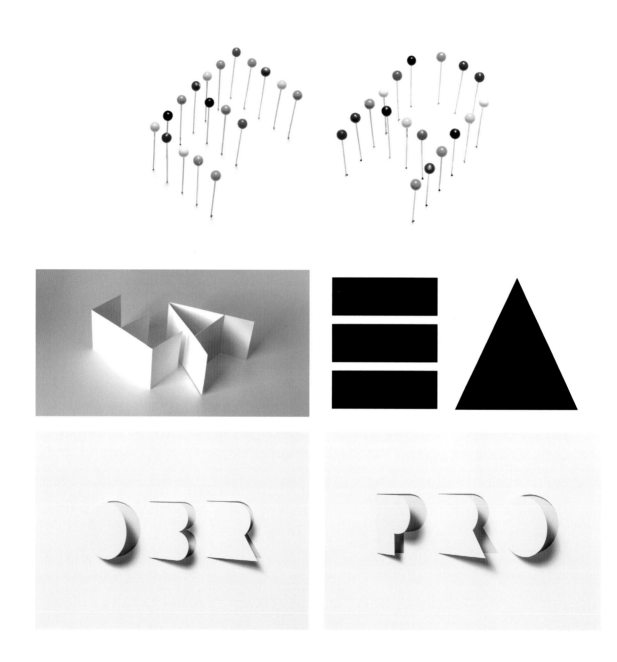

LoSiento worked on other hand-made and three-dimensional
proposals before deciding on repurposing their letters as doors.
This logo is also used on the website.

Feesability

Feesability is a web-based application developed for the legal sector. In a field dominated by bloated desktop applications provided by large anonymous corporations, ideas about the small footprint, ease-of-use, and mobility of a web app, were key aspects the company wanted to communicate through their new brand identity. Ummocrono used data tables, markers, and paper clips in developing that identity. In the end, however, they arrived at something simpler, and was easily scalable in red—a necessity for an app needing a desktop icon. For the text, the designers chose a *Tempera Rose* with soft, rounded corners in an equally warm gray-tone.

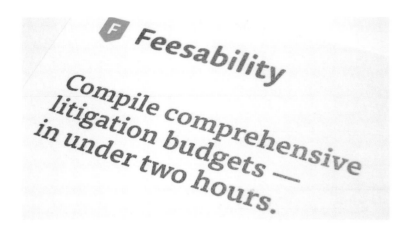

Ummocrono

Ummocrono is a Barcelona-based cross-media design and branding company.

www.ummocrono.com

What is your personal design process?
- Reading about the client, their business and sector, their goals and vision.
- Research and analysis of the sector, and the client's competitors.
- Collecting references and generating ideas (brainstorming).
- Sketching and writing—anything goes.
- Selecting a few ideas with potential and starting to refine them.
- Testing and selecting type.
- Presentation and sign-off of basic concept.
- Develop selected design.
- Final artwork and production of logo in various sizes and formats.

Where did you draw inspiration from for this project?
Visually, our references came from the kind of output an application such as Feesability would typically generate: Gantt charts, flowcharts, numerical tables, and so on.

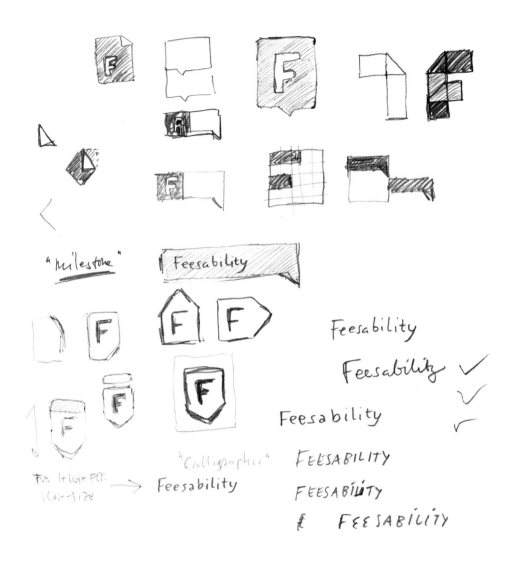

The Ummocrono designers churned out a number of ideas, knowing that the solitary letter *F* would be their major imagistic hook because they needed the logo needle to be scalable and immediately recognizable. After passing over the idea of cartoonish thought bubbles as not conveying Feesability's central message, they decided on a shield shape inspired by road markers, signaling the product's function of giving the user helpful direction.

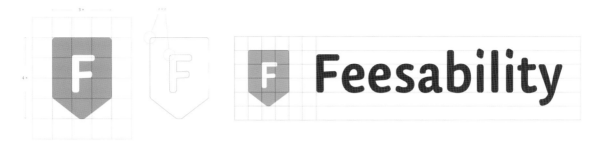

FH MAINZ

FH Mainz University of
Applied Sciences

The symbol created by MAGMA for FH Mainz University of
Applied Sciences is visible in two or three dimensions. It is flat
or has volume, depending on how one looks at it. The graphic
representation of the organization's structure represents
the whole of the university and also its three independent
departments. The bright colors are discriminating and, along
with the typeface, mitigate the severe nature of the form.

MAGMA Brand Design

MAGMA is a design agency with a focus on corporate and brand design, based in Karlsruhe, Germany.

www.magmabranddesign.de

What are the basic rules of logo design?
It's a question: Who is the audience? For a big audience, it's absolutely necessary to be original. You have to make a point in differing from other logos—here is the company or institution, and it is unique and original. Smaller audiences, such as the art world or design scene, give you the opportunity to use strategies like quotation, similarity, or irony—so you can play around a little with originality.

What is your personal design process?
To communicate what, how and where, as well as analysis, concept, experimentation, and definition of the form.

Where did you draw inspiration from for this project?
The idea behind the FH Mainz project was to give an abstract picture of the university's structure; so, the organization and inner structure were used as the basis for the logo. This was the only inspiration.

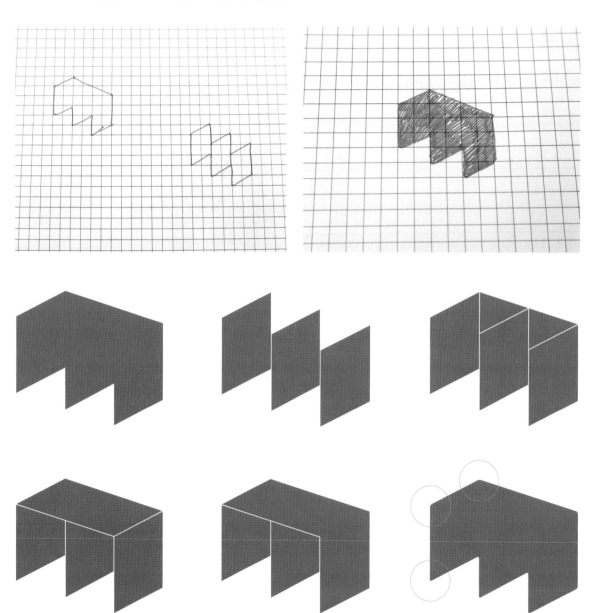

The volumetric structure of the logo is flattened into two
dimensions, and erected as a flag outside the university building.

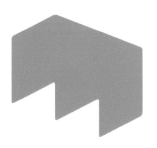

GESTALTUNG
FH MAINZ

ARCHITEKTUR
BAUINGENIEURWESEN
GEOINFORMATIK
FH MAINZ

WIRTSCHAFTS-
WISSENSCHAFTEN
FH MAINZ

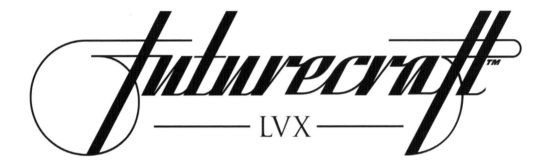

FutureCraft

A self-described champion of "more is more," the graphic artist and illustrator Alex Trochut worked with Streamline Moderne, also known as Art Moderne, an architectural and design style popular in the 1930s, which combines elements of Art Deco with that period's intrigue and excitement for steamships and automobiles. Trochut's client, FutureCraft, the American fashion design company that uses traditional handcraft techniques in its production processes, wanted a logo that combined a hand-made aesthetic with mechanic precision: the hand loom together with more modern techniques.

Alex Trochut

Alex Trochut is a Barcelona-based graphic designer
and illustrator.

www.alextrochut.com

What are the basic rules of logo design?
In my opinion, communication is the most important part of
logo design. You want to get the message across to viewers,
and the sensation that it is sought or required immediately.

What is your personal design process?
In my designs, I do not always follow the same process.
Normally, however, I usually start out by doing research,
then I choose my visual references, and next, I spend time
outlining the ideas, to make a composition on the computer
and define a solid structure. Once done, I figure out what
color treatment should be applied.

Where did you draw inspiration from for this project?
For the FutureCraft project, I mainly used American
Streamline Moderne, which was a variant of Art Deco in the
thirties in the United States.

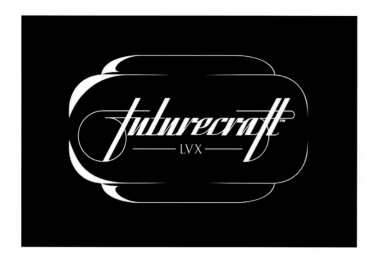

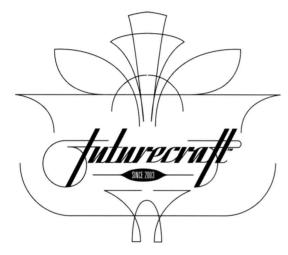

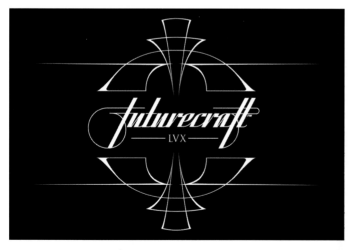

Delicate as a strand of fabric, the graphics for FutureCraft evoke the craftsmanship that characterizes the brand, simultaneously invoking the past and the future. The final version of the logo is a pared-down extension of the designer's earlier attempts to render the name as an emblem that one can imagine emblazoned in chrome on the front of a classic car or on the prow of a 1930s Trans-Atlantic luxury steamship.

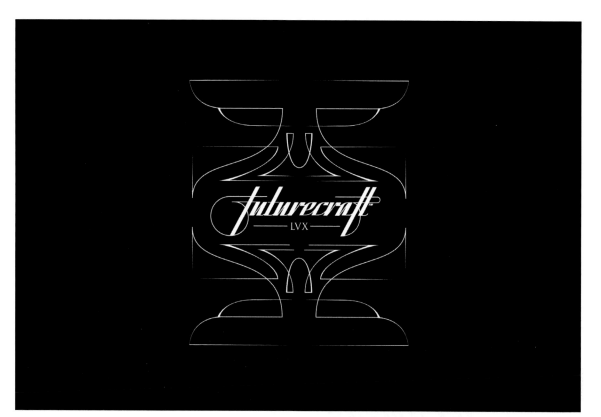

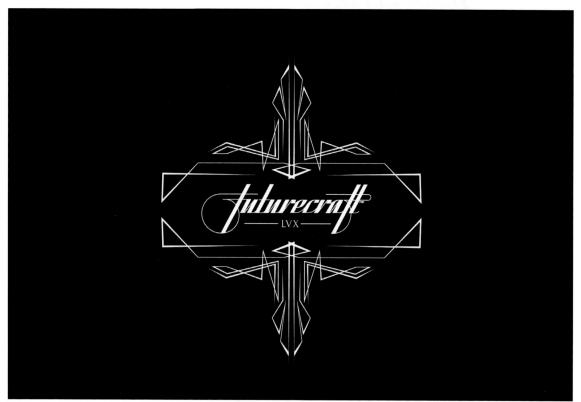

gira

Gira

For the shaping of its own logo, the communication and design studio Gira settled on the typeface Bauer Bodoni. They were interested in linking their brand with the publishing world, and choosing a 1920s variant of a classic Didone typeface allowed them to bring that history with them into their contemporary context. Gira translates as "tour" in English and the reversed G, along with the playful tripling of the dot (which seems to hop across the logo), suggests movement and transience without being too obvious. Rendered in black on white, the logo is always used in the same size and in the same location on the stationery, creating a counterpoint to that fluidity.

Gira

Gira is a communication and design agency based in Barcelona.

www.gira.ws

What are the basic rules of logo design?
In each case, different considerations arise, but usually
there are three basic guidelines: identification, concept,
and form. Sometimes these three parameters are
mixed and interact.

What is your personal design process?
In terms of corporate image, my design process begins
by analyzing customer requirements, that is, their brief.
Often they do not even have one, and you have to create
it yourself. Next, the whole process continues—which is
different in each case—but there is always a preconcept
and typeface approach. Unquestionably, there is also a
search for references and an examination of the competitive
environment in each case.

Where did you draw inspiration from for this project?
I did not want to come up with an easy joke from the name—
which would have been simple—but rather to give it the twist
that the naming required. It was a matter of moderation.
I was sure I wanted a lasting image, derived from a historical
typeface, that would refer to the publishing world, which
is where I come from. Also I wanted to use the minimum
possible resources.

gira gira

gira gira

gira gira

In the early stages of the process, the designers looked to
Futuras and *Helvetica*, but decided that these seemed
to convey impermanence or trendiness, which was not the
direction they wanted to head in. As the conceptual phase
moved forward, the design began to pivot on the use of the
dotted *i*. Turning to the more eloquent *Bauer Bodoni*, they were
able to link the dot to the typeface's bulbous serifs which,
along with its bold main lines, contrasted intriguingly with the
almost impossibly thin hairlines of the *g* and *a*.

gira gira

gira gira

gira r

Gıra gıra

.GIRA

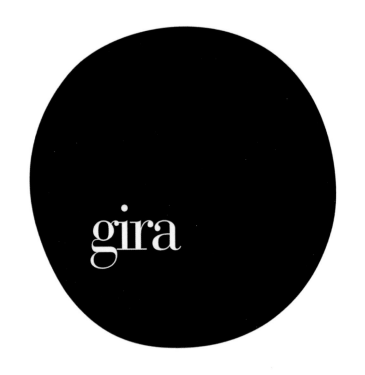

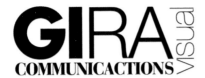

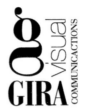

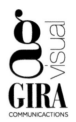

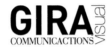

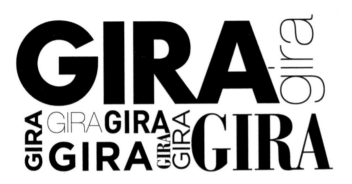

HORROR VACUI

Horror Vacui

"Horror Vacui / Urban Implosions in the Netherlands" was the title of the Dutch exhibition at the Architecture Triennial in Lisbon in 2007. The theme of the exhibition was the increasing urban density of Dutch cities—horror vacui is Latin for "fear of emptiness." Arjan Groot approached the concept of density, horror, and movement in the city through typography (creating a new typeface), typesetting, and by interrogating sources as diverse as the late work of Piet Mondrian, a map of Holland, black tape, and dripping blood.

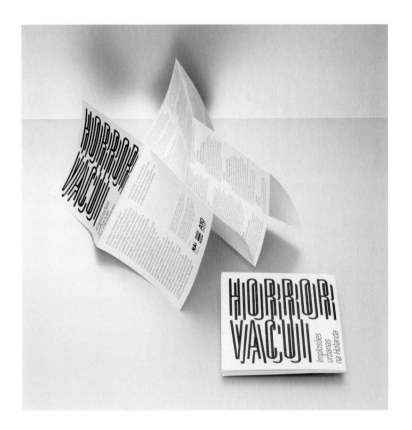

Arjan Groot

Arjan Groot is an award-winning graphic designer based in
Amsterdam. He is also the co-founder of the architecture
journal *A10*.

www.arjangroot.net

Where did you draw inspiration from for this project?
For this project, I was inspired by an exhibition at the
Architecture Triennial in Lisbon, Portugal, the theme of
which was the increasing urban density of Dutch cities.
"Horror Vacui / Urban implosions in the Netherlands" was
its title (*horror vacui* is Latin for "fear of emptiness").

What advice do you have for other designers?
Stay away from 3-D effects.

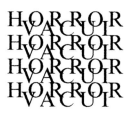

HORROR VACUI

Urban implosions in the Netherlands

Cities in the Netherlands, from Groningen in the north to Maastricht in the south, are undergoing a remarkable transformation. While Dutch cities, with the exception of Almere, are scarcely growing at all in terms of population, a great deal of building is going on. Open areas, 'overshot' zones, and disused port and industrial areas are, or soon will be, turned into new fragments of city, with urban densities and urban-looking buildings; consolidation is under way in city centres and around the railway stations; in nearly every city residential and office towers are under construction or in the pipeline; dual land use is an undeniable trend, manifested in road-straddling construction and tunneling beneath or building on top of existing buildings. The gaps in the urban fabric that were an accepted part of Dutch cities until the mid 1980s, are fast disappearing.

This exhibition is produced by the Netherlands Architecture Institute in collaboration with A10 new European architecture, with financial support from the Netherlands Architecture Fund.

Curators: Hans Ibelings + Kirsten Hannema. Exhibition design: Marta Malé-Alemany + José Pedro Sousa (ReD). Graphic design: Arjan Groot + Julia Müller. Photography: Roel Backaert. Production: Suzanne Kole + Marinke van der Horst. Supervisor: Martien de Vletter. International coordinator: Agnes Wijers.

Special thanks to: AAS Architecten, ARCADIS Bouw en Vastgoed BV, Architectenbureau Art Zaaijer, Architectenbureau Marlies Rohmer, Architectuurstudio Herman Hertzberger, Atelier Rijksbouwmeester, Benthem Crouwel Architekten BV, Bouwfonds MAB Development, Bureau B+B stedebouw en landschapsarchitectuur, City of Eindhoven, City of Tilburg, Claus en Kaan Architecten, De Architekten Cie, De Zwarte Hond, Department of Physical Planing and Economic Affairs Groningen, Department of Physical Planning Amsterdam, Dick van Gameren architecten B.V, Dienst Stedelijke Ontwikkeling – City of The Hague, dS+V Rotterdam, (EEA) Erick van Egeraat associated architects, FARO Architecten bv, FPW Rotterdam, hvdn Architecten, JHK Architecten, Jo Coenen & Co Architecten, KCAP Architects&Planners, Köther | Salman | Koedijk | Architecten bv, Meyer en Van Schooten Architecten BV,

MVRDV, NL Architects, OD 205 architectuur bv, Office for Metropolitan Architecture, OMS Beheer bv (City of Lelystad and William Properties bv), ONL [Oosterhuis_Lénárd], Ontwikkelingsbedrijf Rotterdam, Pierre Gautier architecture, PPKS Architects Ltd., Project Organisation Stationsgebied – City of Utrecht, Projectbureau Amsterdam Zuidas – City of Amsterdam, Projectbureau Zuidelijke IJ-oevers – City of Amsterdam, Rijnboutt Van der Vossen Rijnboutt bv, S333 architects, Soeters Van Eldonk Architecten, Stadsdeel Geuzenveld-Slotermeer – City of Amsterdam, Tania Concko Architectes, THALEN/BASELINE, UN Studio, Van Sambeek & Van Veen Architecten, Vera Yanovshtchinsky architecten, vof ontwikkelingscombinatie IMA (ING, MOESbouw, AM), West 8 urban design & landscape architecture b.v., Wiel Arets Architects, Ymere Ontwikkeling, Zwarts & Jansma Architects

Groningen

Lelystad
Zaanstad
Amsterdam
Enschede
Den Haag
Utrecht
Arnhem
Rotterdam

Tilburg
Eindhoven

Maastricht

While Groot toyed with more gothic scripts to bring out the first word of the title, "horror", the meaning of the Latin phrase proved to be more salient for the designer—"The fear of emptiness." This inspired a logo in which very condensed sans serif capital letters overlapped each other in layers, producing a vibrating, shuddering effect that seems to echo itself and easily recalls our all-too-familiar, overstuffed, contemporary cityscapes.

IDTV

A pixel is the smallest autonomous unit in the makeup of a
digital image. It is the basis of any onscreen image, and from
this fact is derived the pixel's relevance to the identity of IDTV.
For this Dutch television and film production company, Lava
created an original visual DNA comprised of these bits of digital
information. Four pixels are combined and scaled to draw a
variety of designs—a system that is, in itself, a visual brand,
versatile enough to include the potential image of all IDTV
initiatives yet to come.

Lava

Lava is a design studio founded in 1990 in Amsterdam.

www.lava.nl

What is your personal design process?
There is a balance between the tasks of the creative team
and the client team that is needed to create a mature,
dynamic identity. Clients need to become champions of the
new identity.

What lessons have you learned about logo design or what do
you wish you had known?
Every organization has an identity according to different
scales of maturity:
1. The most basic level is a logo identity. The identity is only
expressed through a logo.
2. For a visual identity, we add a visual language.
3. Any mature organization needs a corporate identity to
express its "body." At this level, we have an identity manual,
where the use of the logo, typography, art direction of
images, color systems, and tone of voice are highlighted.
4. At the most mature level, a brand identity is a personality,
so it is expressed across everything the organization does.

What advice do you have for other designers?
Read outside of design. Within nature we can see the best
examples of the paradoxes we face in design: flexibility with
strength, lightness with durability, unity in diversity. Our
world is facing new challenges. It is our responsibility to work
toward making it a better place.

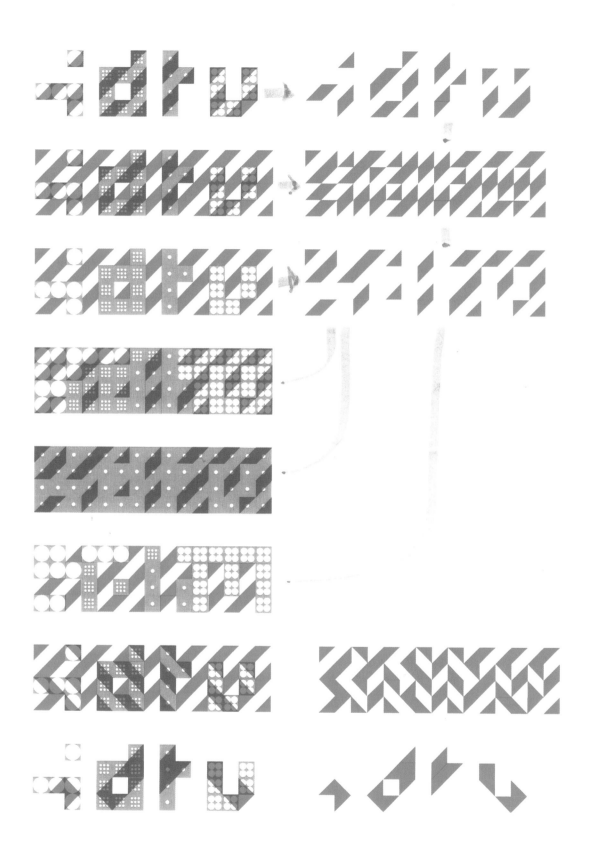

For this logo, Lava went purely techno—there is nothing handdrawn about this design. It is made onscreen in order to represent a company that creates by using the screen.

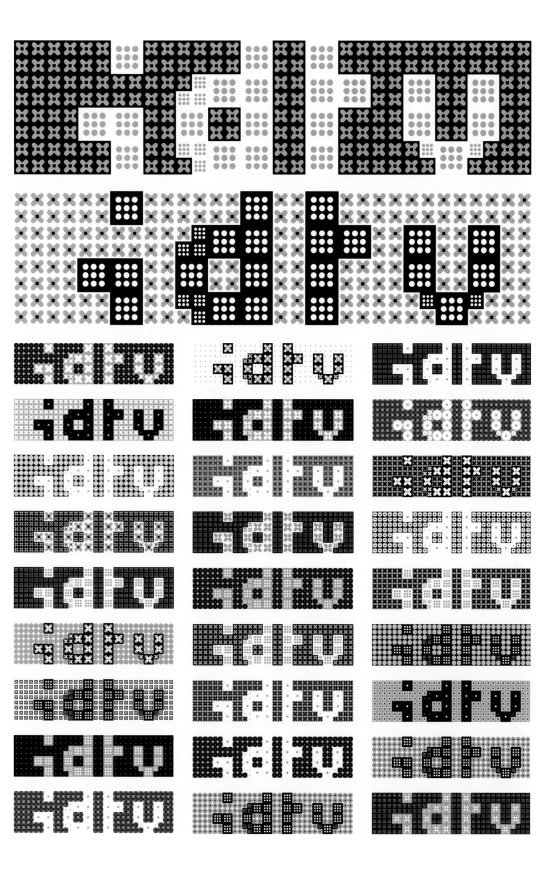

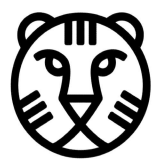

INTERNATIONAL FILM FESTIVAL ROTTERDAM

International Film Festival Rotterdam

The new logo imprint of the International Film Festival Rotterdam aims to highlight the idiosyncrasies of the Dutch institution and its ability to look to the future. This is a redesign done by 75B in 2008, and it brings together the line drawing of a tiger head next to the name of the festival written in capital letters. Both the tiger and the text are confrontational and direct while not intimidating or overwhelming the viewer. The tiger is considered the King of Beasts in Asian countries, besting the lion, and demands respect, reverence, and attention world-wide. In representing the International Film Festival Rotterdam, the designers have chosen a symbol that asks potential spectators—in this case nicely, but firmly—to take notice.

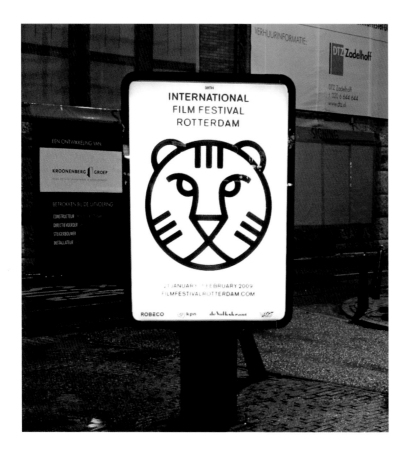

75B

75B is a multi-designer graphic design and branding firm based in Rotterdam in the Netherlands.

www.75b.nl

Where did you draw inspiration from for this project?
For the International Film Festival Rotterdam, we were inspired by youth and music subcultures, and also by politcal icons such as the peace sign, the anarchy sign, the logo of the band the Dead Kennedeys, and the smiley face. Our inspiration comes from everywhere, except books on graphic design. We try not to make something that is nice or beautiful, but something that stays in your head, and has a timeless power. Then it becomes beautiful.

What advice do you have for other designers?
Choose a serious profession.

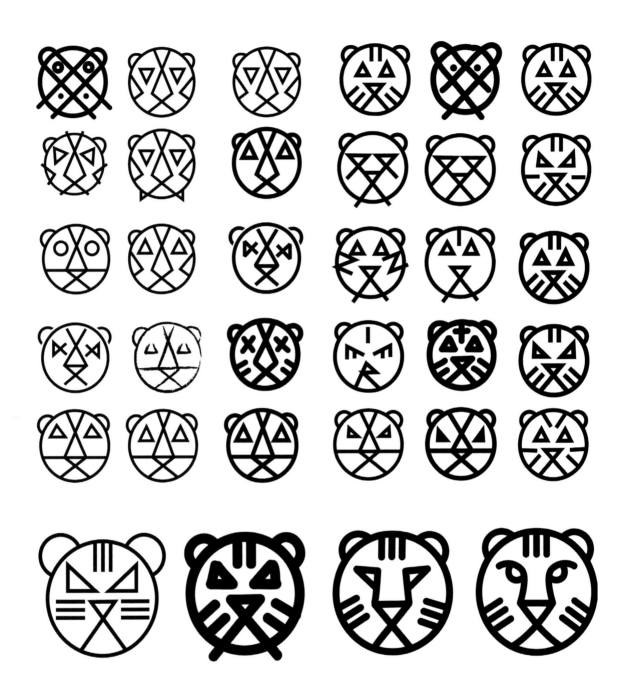

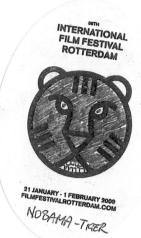

38TH
INTERNATIONAL
FILM FESTIVAL
ROTTERDAM

21 JANUARY - 1 FEBRUARY 2009
FILMFESTIVALROTTERDAM.COM

NOBAMA-TIGER

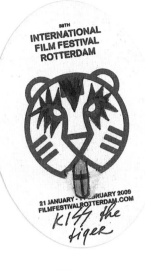

38TH
INTERNATIONAL
FILM FESTIVAL
ROTTERDAM

21 JANUARY - 1 FEBRUARY 2009
FILMFESTIVALROTTERDAM.COM

KISS the tiger

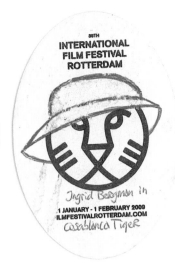

38TH
INTERNATIONAL
FILM FESTIVAL
ROTTERDAM

Ingrid Bergman in

1 JANUARY - 1 FEBRUARY 2009
ILMFESTIVALROTTERDAM.COM

Casablanca Tiger

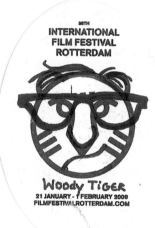

38TH
INTERNATIONAL
FILM FESTIVAL
ROTTERDAM

Woody Tiger

21 JANUARY - 1 FEBRUARY 2009
FILMFESTIVALROTTERDAM.COM

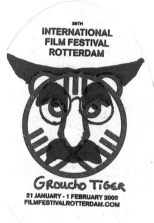

38TH
INTERNATIONAL
FILM FESTIVAL
ROTTERDAM

Groucho Tiger

21 JANUARY - 1 FEBRUARY 2009
FILMFESTIVALROTTERDAM.COM

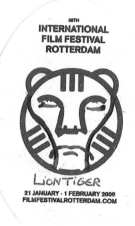

38TH
INTERNATIONAL
FILM FESTIVAL
ROTTERDAM

LionTiger

21 JANUARY - 1 FEBRUARY 2009
FILMFESTIVALROTTERDAM.COM

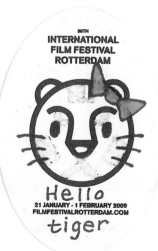

38TH
INTERNATIONAL
FILM FESTIVAL
ROTTERDAM

Hello

21 JANUARY - 1 FEBRUARY 2009
FILMFESTIVALROTTERDAM.COM

tiger

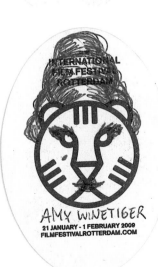

38TH
INTERNATIONAL
FILM FESTIVAL
ROTTERDAM

AMY WINETIGER

21 JANUARY - 1 FEBRUARY 2009
FILMFESTIVALROTTERDAM.COM

38TH
INTERNATIONAL
FILM FESTIVAL
ROTTERDAM

21 JANUARY - 1 FEBRUARY 2009
FILMFESTIVALROTTERDAM.COM

CLINICLOWN
TIGER

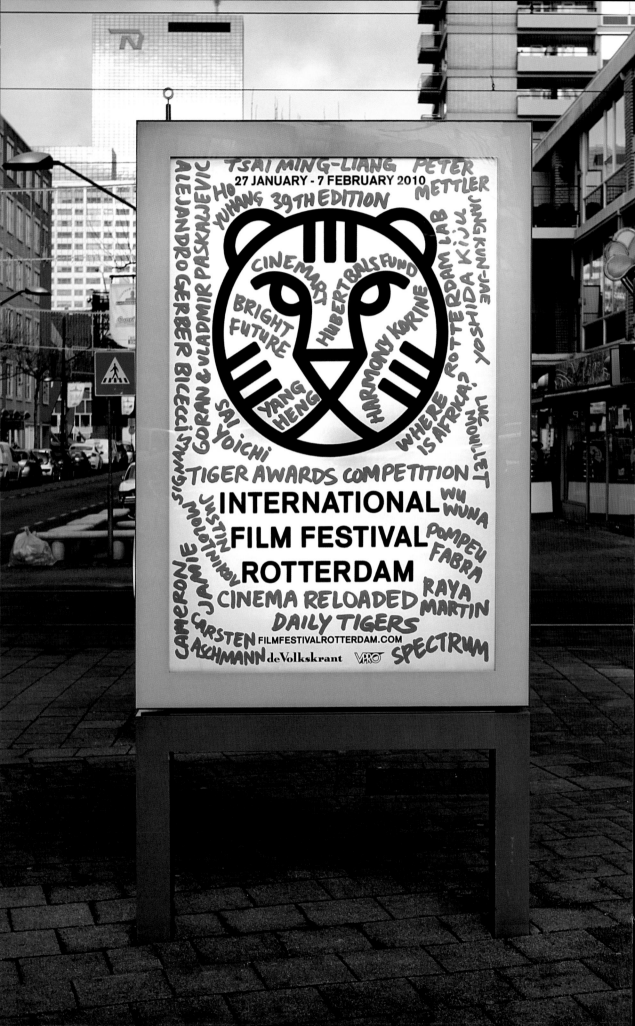

After a wide-ranging graphic examination of the lion's face
that ran from ornate, to cartoonish, to abstract, simplicity and
a friendly, inquisitive expression is evident in the final design.
As seen in the photograph, the negative space of the lion's face
creates the possibility for the logo's usefulness to be stretched
beyond the original concept.

LAB111

Lab111

Lab111 is a restaurant in Amsterdam that shares a building with Smart Project Space, a contemporary center dedicated to art and film for which Arjan Groot had already created a logo in 2001. So, in 2008, the restaurant owners asked for a continuation of the style and an evocation of the first logo. They also asked that it be in the same font, a customized version of Helvetica. Without the need for conceptual elaborations, Groot worked with graphics and detail in pursuit of the best composition.

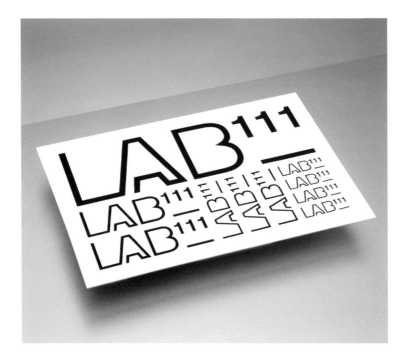

Arjan Groot

Arjan Groot is an award-winning graphic designer based in
Amsterdam. He is also the co-founder of the architecture
journal A10.

www.arjangroot.net

What are the basic rules of logo design?
I like logos that are designed not as isolated objects, but as
a logical result of the visual principles that form an identity.
However, the challenge in designing a good logo is to make it
work within its own conceptual environment (which is relatively
easy) and at the same time in a completely different—possibly
even "hostile"—visual context that is beyond your control.

What lessons have you learned about logo design or what do you
wish you had known?
Be serious, not just rational. A good logo results from a
combination of rational decisions and a certain dose of
irrationality. When designing a logo, or when designing in
general, small mistakes or misunderstandings can open new
areas that can't be reached with a purely rational approach.

SMART
PROJECT
SPACE

LAB111 LAB111

LAB
111

LAB 111 LAB 111

LAB 111 LAB111 LAB111

LAB111 LAB111 LAB111

Because the work of creating the font had already been done
years earlier, Groot was free to make composition his primary
concern. While any of his many variations might have worked,
Groot and his clients selected a version with a slightly heavier
line than the Smart Project Space logo from 2001, but which
prominently utilizes the underscore that is also featured in the
earlier logo.

LAB¹¹¹ LAB¹¹¹ LAB¹¹¹

LAB¹¹¹ LAB¹¹¹ LAB

 111

LAB¹ LAB ᴸᴬᴮ
 111 1 1 1

ᴸ1ᴬ1ᴮ1 LAB¹¹¹ LAB¹¹¹

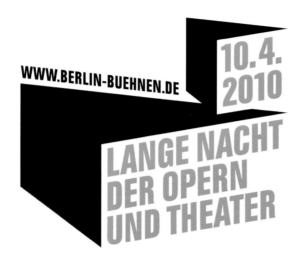

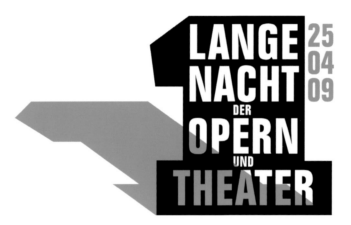

Lange Nacht der Opern und Theater

In 2009, Formdusche came up with the logo for the first Lange Nacht der Opern und Theater (Long Night of Opera and Theater) in Berlin. The designers took their inspiration from the notion of the passage of time from day into night, sculpting their logo from light and shadow. Of course, in addition to natural light, theatrical light played into the concept significantly, casting the numeral one in the primary role and catching it in the spotlight of green. In 2009, the numeral one was the prominent feature. However, it was not needed for subsequent editions, and the entire design was reformulated to prioritize other areas such as space, setting, and decor.

Formdusche

Formdusche is a full-service design company based in Berlin.

www.formdusche.de

What are the basic rules of logo design?
We are guided by a simple principle: Form follows content.
In order to get the desired idea across, all areas of design
need to be included—form, color, material, the medium.
It is always preferable to draw up a variable and adaptive
concept by using a set of rules that are easy to grasp (a
logo-building kit so to speak), and have several variants,
instead of insisting on a restrictive and inflexible design.

What is your personal design process?
Finding the exact message, the adequate implementation,
and a versatility of application on top of clear and
recognizable elements. Catchy moments, an intelligent
idea (which can provide eureka moments for the observer),
tailor-made solutions for the client, striking and immediate
visual connection.

What advice do you have for other designers?
1. Form follows content.
2. Simplicity works.
3. Be decisive and follow your ideas.

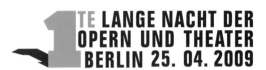

TE LANGE NACHT DER OPERN UND THEATER BERLIN 25. 04. 2009

TE LANGE NACHT DER OPERN UND THEATER BERLIN 25. 04. 2009

TE LANGE NACHT DER OPERN UND THEATER BERLIN 25. 04. 2009

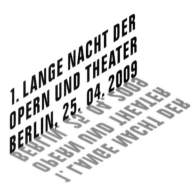

One can easily see the invention of the 2009 logo on this page and its development in 2010 on the following. The visual language and typography change very little because Formdusche created an image that was pliable and could be recast in a variety of medium.

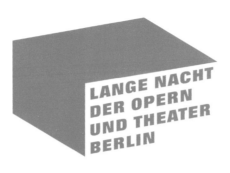

LANGE NACHT
DER OPERN
UND THEATER

LANGE NACHT
DER OPERN
UND THEATER

LANGE NACHT
DER OPERN
UND THEATER

LANGE NACHT
DER OPERN
UND THEATER

LANGE NACHT
DER OPERN
UND THEATER

LANGE NACHT
DER OPERN
UND THEATER

Luigi Bosca

In 2009, the Diseño Shakespear studio was asked to streamline and update the Luigi Bosca brand, along with the design (and in some cases the redesign) of their product packaging. This Argentinian bodega is almost one hundred years old, and many changes to its logo over the years had distorted its public image. Subtle, appropriate calligraphic touches were made to the gestural logo without affecting its recognizability. The founders of the company, the Arizu Family, added the logo to the family coat of arms in order to strengthen the mutual connection.

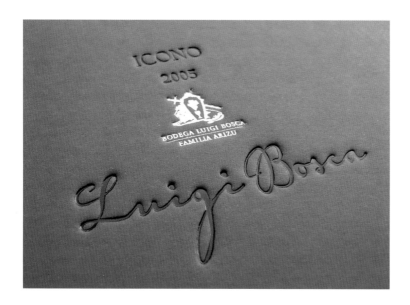

Diseño Shakespear

Lorenzo Shakespear / Juan Shakespear / Ronald Shakespear / Martina Mut / Eliana Testa / Gonzalo Strasser / María Spitaleri / Claudio Sarden / Juan Hitters / Héctor Calderone

Diseño Shakespear is a Buenos Aires-based branding, marketing, and design firm.

www.webshakespear.com.ar

What are the basic rules of logo design?
First, you have to interpret the audience. Defining the recipient implies being aware of their cultural background, habits and customs, desires and emotional preferences. Then, you need to move forward in search of an aesthetic suitable for that audience.

What is your personal design process?
The preliminary research process is essential. It allows not only for checking the background of the subject, but also it avoids conflicts over alleged similarities with existing logos. The research also immerses us in the subject and is a source of inspiration for development.

What advice do you have for other designers?
To overcome the stress and panic of a blank page, you must plan your work meticulously and not leave findings to chance. Shaping the project is a task for both client and designer. When the customers are not part of the solution, they are part of the problem.

Luigi Bosca

Luigi Bosca

Luigi Bosca

Luigi Bosca

Luigi Bosca

Luigi Bosca

Luigi Bosca

Luigi Bosca

Luigi Bosca

Luigi Bosca

Luigi Bosca

LUIGI BOSCA

Luigi Bosca

LUIGI BOSCA

Luigi Bosca

LUIGI BOSCA

With a remit to update without denigrating the company's logo, the designers at Diseño Shakespear tried a number of approaches, finally resting on a version which is lighter and less severe than its predecessor, shown at the top of the second column.

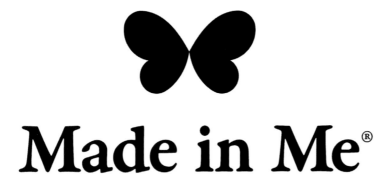

Made in Me

Made in Me is an educational game application for children aged two and above, which involves children working alongside their parents or teachers in front of the screen. Stylo experimented with a plentiful array of characters and ornamentation that gave way, on a final attempt, to a quite simple solution: a butterfly in a spot of color for the icon and a slightly tweaked *Garamond* for the name. The butterfly is frequently used in the interactive universe of the game, which gives the logo an interesting symbiosis with the product it represents. The designers knew that the aesthetic of the game's packaging should not only be attractive to both children and adults, but it should also align with the classic style of children's literature.

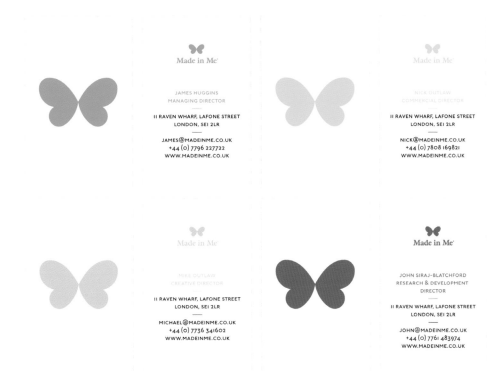

Stylo Design

Stylo Design is a multi-disciplinary design and digital consultancy firm based in central London.

www.stylodesign.co.uk

What are the basic rules of logo design?
- Simple is often, though not always, best.
- Listen to your client. They know more about their business than you do.
- Start with pen and paper.
- Despite the proliferation of on-screen design, a logo should still always work in black and white.
- It should be scalable, with the usual minimum size being about what you'd see on a business card.

Where did you draw inspiration from for this project?
The client wanted an icon that would represent playfulness and would appeal to children. The typography, a touched-up variant of Garamond, is intended to convey the classic storytelling aesthetic inspired by the product, an interactive, educational tool for children.

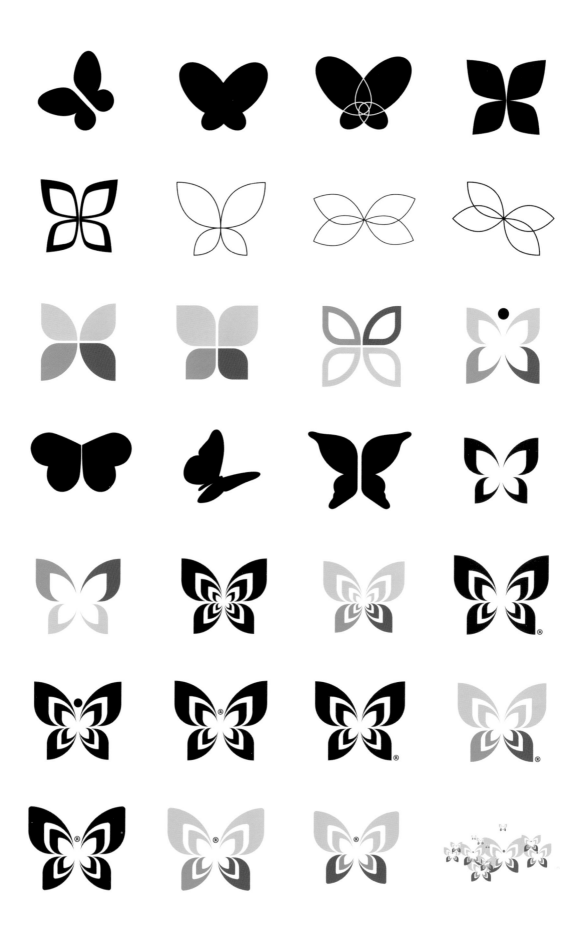

Made in Me®

Made in Me®

Made in Me®

Made in Me®

Made in Me®

Stylo's extensive imaginings and re-imaginings of Made in
Me's identity, evolved from pencil sketches circling around the
first letters of the game's name, to bright, flora-encrusted
renderings of the title, to eventually emerge as a butterfly full
of color. The color palette was inspired by Disney's *The Jungle
Book*; green, turquoise, yellow, and blue were used for the
final version.

My Fonts

For the new stage of the prolific online typography store, My Fonts, Underware took a risk by opting for a logo that informs the user of its privileged position. Originally hand painted, the logo indelibly preserves its spontaneous stroke and transmits its notions of creativity, individuality, and DIY production. By placing the user at the center of the experience, the designers have reinforced the typographic variety as the company's primary value, and they were able to explore other graphics solutions beyond the multitude of typefaces.

Underware

Underware is a pan-European design collective based in the Hague, Helsinki, and Amsterdam, specializing in font creation.

www.underware.nl

What is your personal design process?
We don't have a specified process. Once we are fascinated, the rest follows by itself.

Where did you draw inspiration from for this project?
If we knew (and could put into words) what inspires creativity, we would change our design career into a mental coaching career, earn money with royalties from book sales, make lots of money with presentations, buy a Rolex and a Mercedes, pick up of lots of young party girls, and go wild forever. Unfortunately, it's not so simple.
I remember for this project it took lots of sketching before we suddenly—surprise, surprise—found the hand in the name.

What lessons have you learned about logo design or what do you wish you had known?
You have to be damn lucky to discover that a company's name coincidentally goes hand in hand with an illustrative ambigram. In many cases, you don't have a chance at all, but this time we were lucky.

As the designers engaged in a creative frenzy of freehand
sketches, the outline of a hand began to emerge, and
Underware knew how to make good use of it.

museum of arts and design

New York's Museum of Arts and Design

Combining and modifying the basic shapes of squares and
circles, the Pentagram partners Michael Bierut and Lisa
Strausfeld came up with a powerful cypher for New York's
Museum of Arts and Design (MAD), and created a full typeface
for it called MAD Face. The geometric shapes were inspired by
the recent project to refurbish the building, which is located
in Columbus Circle, and the rounded edges of the typeface
doubles the swirling circles of the building's environs.

Pentagram

Pentagram is the world's largest independent design consultancy. The firm is owned and run by sixteen partners, a group of friends who are all leaders in their individual creative fields. Pentagram and its partners work out of London, New York, Berlin, and Austin.

www.pentagram.com

What are the basic rules of logo design?
There are really no official "rules" for designing a logo. Each client is different, each context is different. On top of that, each designer is different. A range of approaches is what makes design (and life) interesting.

What is your personal design process?
When designing a logo or anything else, you should make sure you know as much as possible about your client and your client's audience. The more you know, the better your work will be. It's that simple.

Where did you draw inspiration from for this project?
The geometric-based marque reflects the circles and squares present in the building's shape, its location on Columbus Circle——the only circle in Manhattan's street grid——and the building's iconic "lollipop" columns, which were retained in the redesign.

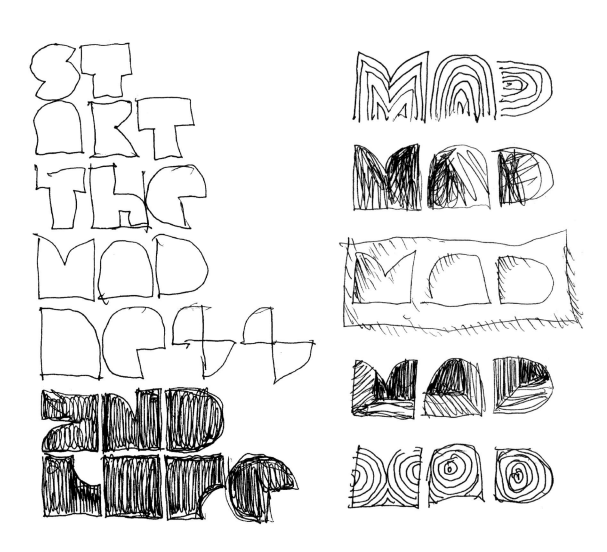

Looking at the several sketches of Pentagram's proposals,
one can see an interest in reflecting architecture and the
materiality of typography. In one version, the letters are portals
into the museum, signaling the intrigue that can be found for
the art and design lover through MAD's overarching concept.

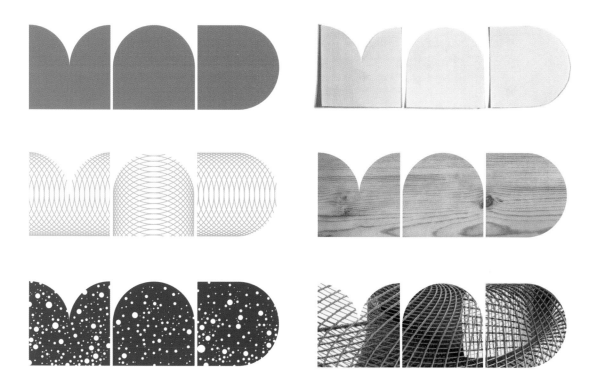

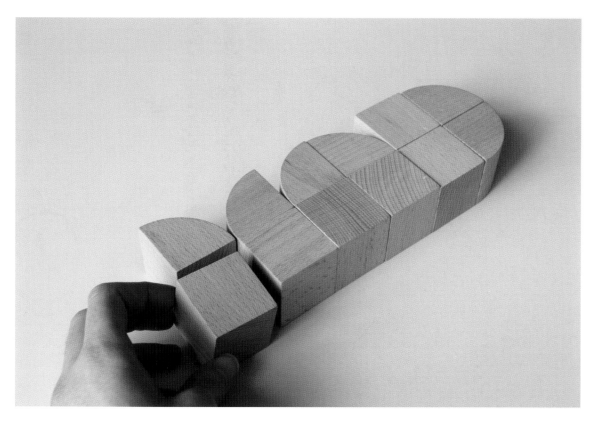

Nippon Sense

Nippon Sense's furniture design is a mixture of traditional
Japanese and contemporary international. It is sponsored by
the city of Shizuoka, and has the support of the Italian designer
Sergio Calatroni. Indeed, it was in Calatroni's studio that this
hypnotic symbol was designed. The effect of a drop of water
on the circular plane of the Japanese flag conveys the stylish
subtlety of Nippon Sense's work, and conveys that complex
admixture of the traditional and local with the contemporary
and global.

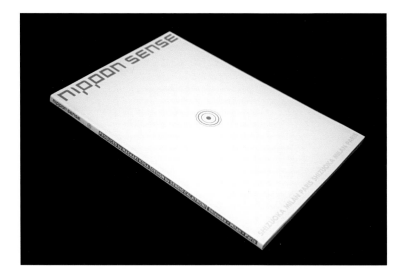

Artroom

Artroom is the name of the full-service design, branding, and illustration company headed by Sergio Calatroni, based in Milan.

www.sergiocalatroni.com

What are the basic rules of logo design?
We get to know the client's world. This is the most basic necessity in order to create a logo. The inspiration can come only after we have all the input from the client. We have to surprise ourselves, and surprise means doing something new. To create something new, there are no rules—the only spice that we use is art.

What advice do you have for other designers?
Don't copy and past. Instead, delete and create anew.

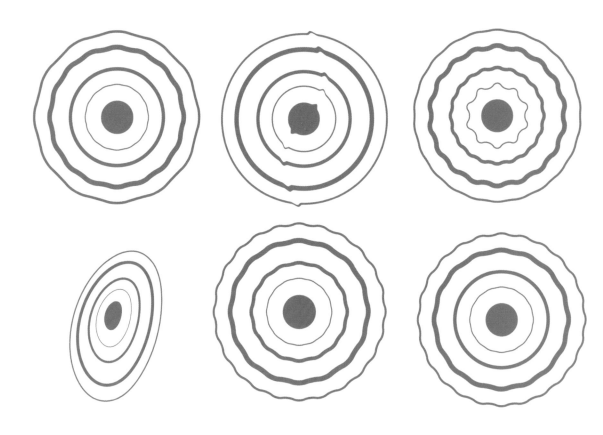

The small, red-on-white symbol in the middle of the Nippon Sense catalog gives an added effect of a bull's eye, marking what lays inside as something for the consumer to aim for.

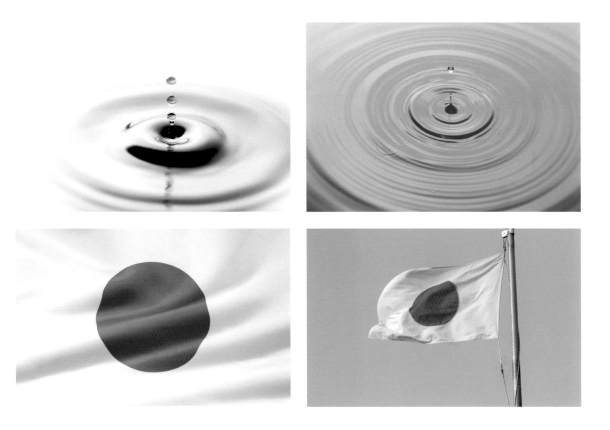

North Ridge Films

North Ridge Films, a small production company based in London and Spain, used the extraordinary symbolic power of the north face of Mount Everest when choosing its name. These producers of documentary movies, promotional movies, and short and long programs, turned to what is traditionally known as the more exacting route to reach Everest's summit, thereby conveying their dedication to taking the harder route if necessary. The icon of a mountain was an obvious choice for Stylo Design, which cast the logo in cool shades of blue and crafted an image of a mountain that seems to float effortlessly in space in order to counteract the potential struggle the name might suggest to some potential clients.

Stylo Design

Stylo Design is a multi-disciplinary design and digital
consultancy firm based in central London.

www.stylodesign.co.uk

Where did you draw inspiration from for this project?
The client's name is derived from the iconic north face
of Mount Everest—traditionally the hardest route to the
summit. It was selected as a representation of their ethos.

**What lessons have you learned about logo design or what do
you wish you had known?**
Client input at the preliminary stage is all-important. What
are their likes and dislikes? Inspiration? What typography
inspires them—if any? What do certain colors mean to them?
We ask clients to complete a preliminary "discovery phase,"
during which we gather as much resource material and
information as possible. This helps to avoid lengthy forays
down the wrong path, and results in a better solution.

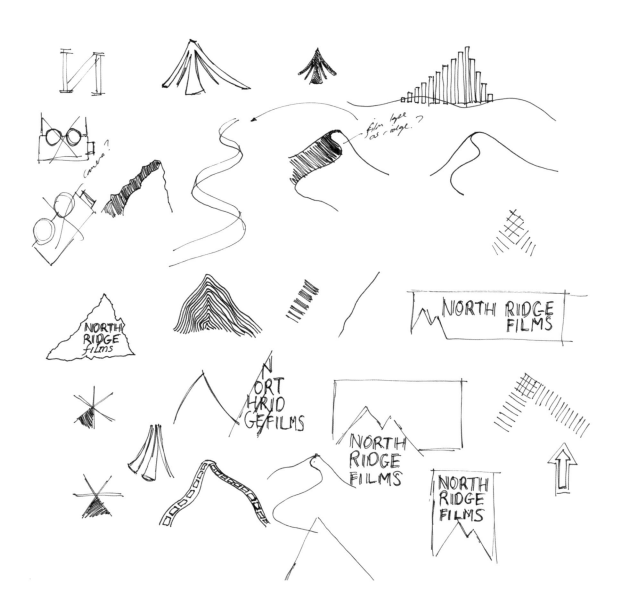

NORTH RIDGE FILMS

NORTH RIDGE FILMS

NORTH RIDGE FILMS

NORTH RIDGE FILMS

NORTH RIDGE FILMS

NORTH RIDGE FILMS

NORTH RIDGE FILMS

NORTH RIDGE FILMS

NORTH RIDGE

 NorthRidgeFilms

Logo

Logo Construction

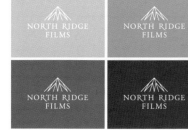

Logo Marque

Logo White Out Colourways

Logo Type

Logo Colourways

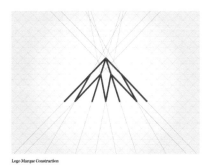

Logo Marque Construction

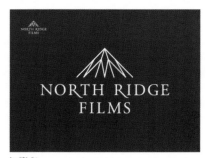

Logo White Out

While the designers cycled through a range of ideas that included other elements drawn from nature, as well as the vocabulary of film, and the metaphor of direction through an effort to utilise the compass rose, they ultimately rested on the most straightforward symbol: the mountain peak. For the lettering they chose the sophisticated but tough-minded *Garamond BE*, slightly tweaked in the *R*.

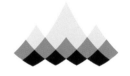

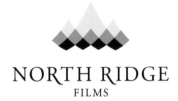

Nuno

The strong graphic logo developed by Bleed for the Norwegian architectural firm Nuno, acts as a visual counterpoint to the phonetic delicacy of the name. The word Nuno is meaningless— it is the result of an entirely chance selection of letters carried out by the architects of the firm—and so they were looking for a strong and somewhat rough logo that suited the construction world. The closed forms of the typeface are created from simple geometric figures, while the stencilled look draws a connection to graffiti and a roughhewn, urban vocabulary.

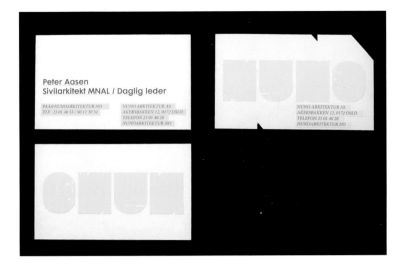

Bleed

Bleed is a multi-disciplinary design consultancy based in Oslo, Normay, working to challenge today's conventions around art, visual language, media, and identity.

www.bleed.no

What are the basic rules of logo design?
Research is important in all design. You should be familiar with the client's company, aspirations, dilemmas, and competitors. Good background information is the best starting point. It makes it easier to see which ideas have enough punch to separate a client from their peers, move that client forward, and give them a competitive edge.

What is your personal design process?
1. Googling the client and their competition to get a thorough view of their market segment. For a larger project, a strategic analysis/debrief would be included for this part.
2. Brainstorming freely to find an angle that could give the client a creative push.
3. Doing a thorough search for inspirational imagery. Making a moodboard.
4. Sketching on paper.
5. Narrowing down to two or three ideas, and exploring one or two ideas further.
6. Presenting to the client.

Where did you draw inspiration from for this project?
We wanted to create the impression of a shape that looked like it could be carved out of stone. Together, with the usage of basic geometric shapes, that was the initial starting point. Talking freely with the client about these things was the perfect start for the creative process.

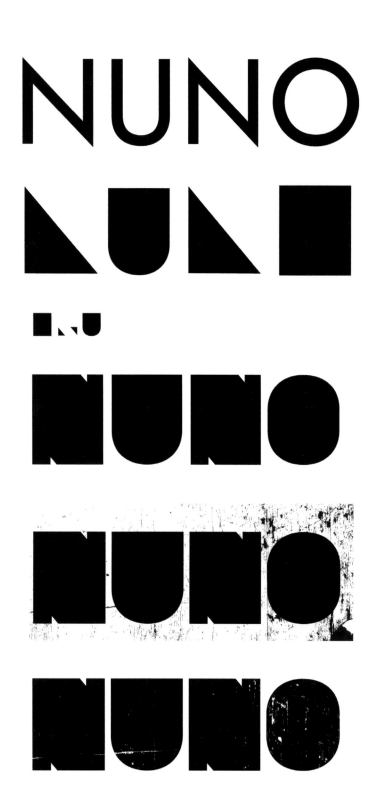

Beginning with a typeface that was considerably more crisp and clean, the designers at Bleed quickly moved to a blockier style that obfuscated the meaning of the nonsensical word—or removed the necessity of meaning in the first place. The chunky letters do recall stencil, which points to graffiti, but more importantly, the uneven color treatment immediately puts the viewer in mind of paint applied to concrete, which is foreground to Nuno's architectural interests.

Badets identitet
gis av bildet
man møter når
man ankommer
Idrettsparken.

RISENGA BAD

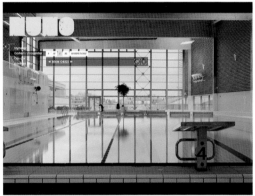

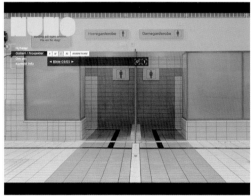

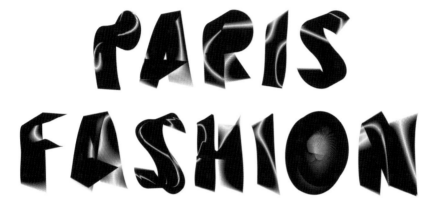

Paris Fashion

Paris Fashion's clothing and accessories make use of unusual twists and seductive hidden messages like tiny pockets, rotated sleeves, suggestive textile patterns. In short, they are attracted as much to the folds of the fabric as a fashion accessory, as they are to the final piece. Pinar&Viola came up with their logo image from this characteristic standpoint, investigating the artistic possibilities of origami planes and the intricacies of folds and creases, whether in paper or fabric. This research led to a font with frozen folds and graphic motifs based on origami patterns, but with an added stroke of Japanisme in the form of near calligraphic marks that might recalled the Japanese influence on the signs and posters of French Modernists like Toulouse Lautrec.

Pinar&Viola

Pinar&Viola is an Amsterdam-based graphic design company comprised of Pinar Demirdag and Viola Renate, specializing in what they describe as "ecstatic surface design."

www.pinar-viola.com

Where did you draw inspiration from for this project?
For Paris Fashion, we were inspired by crease, origami, sewing patterns, Lycra, and some flashy razzle-dazzle.

What lessons have you learned about logo design or what do you wish you had known?
During the design process, we realized that when creating a logo you shouldn't strive for perfection, but focus instead on creating a compelling design.

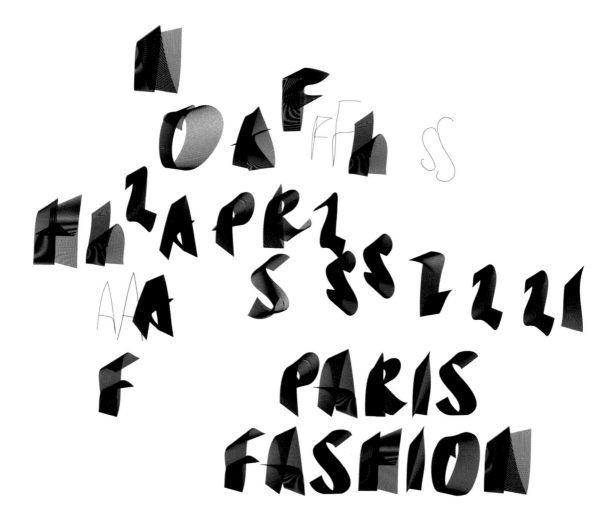

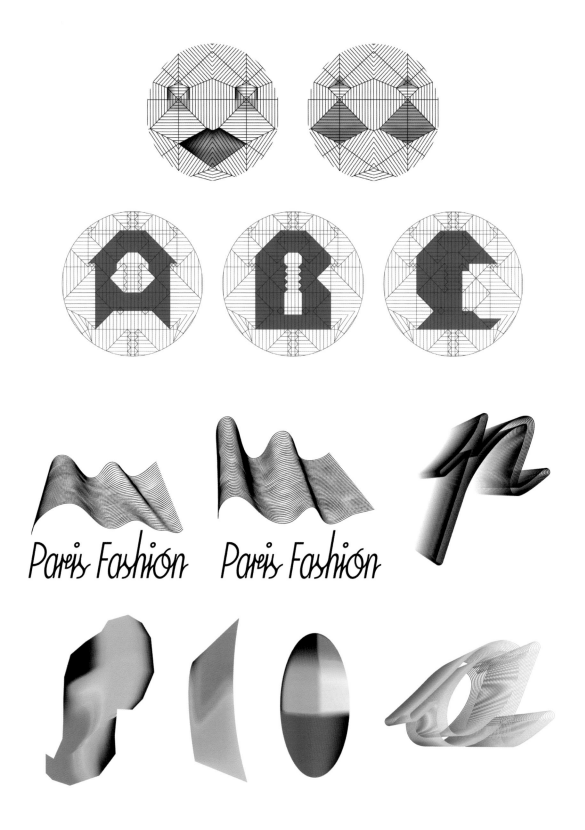

Pinar&Viola attempt to challenge the territory of graphic design by exploring the seductive nature of the more diverse surfaces such as folded paper. One early, purely graphic stamp was considered too abstract and not communicative enough.

pedro garcía

pol. campo alto, c/italia 46
03600 elda, alicante/españa
tel +34 96 539 90 07
fax +34 96 539 48 46
info@pedrogarcia.com
www.pedrogarcia.com

Pedro García

The new brand identity for Pedro García shoes rests on a bold and classic logo in which a refined touch is provided by *Caslon 540*. The Cla-se studio has developed a complete visual system from this font and texts arranged according to basic rules. The typeface is always applied in black and white, composed in left box pennant, and in lowercase text, with only the name of the company resting in an upper body. The text block contains the full address and company information.

Cla-se

Cla-se is an award-winning Barcelona-based full-service design firm.

www.clasebcn.com

What are the basic rules of logo design?
For the logo design, basically, the simplicity of the concept, the timelessness, and the contemporary are all considered. We seek innovation both in the form and the capacity for suggestion.

Where did you draw inspiration from for this project?
For the Pedro Garcia project, the idea was to create a seal or a stamp, rather than the usual logo, in reference to the "stamping" of the shoes. The overall identity emerged from this same concept.

What lessons have you learned about logo design or what do you wish you had known?
The first ideas are almost always the best.

pedro garcía
pol. campo alto, c/italia 46
03600 elda, alicante/españa
tel +34 96 539 90 07
fax +34 96 539 48 46
info@pedrogarcia.com
www.pedrogarcia.com

pedro garcía
pol. campo alto, c/italia 46
03600 elda, alicante/españa
tel +34 96 539 90 07
fax +34 96 539 48 46
info@pedrogarcia.com
www.pedrogarcia.com

pedro garcía
pol. campo alto, c/italia 46
03600 elda, alicante/españa

tel +34 96 539 90 07

fax +34 96 539 48 46

infoedrogarcia.com

www.pedrogarcia.com

pedro garcía
pol. campo alto, c/italia 46
03600 elda, alicante/españa
tel +34 96 539 90 07
fax +34 96 539 48 46
info@pedrogarcia.com
www.pedrogarcia.com

pedro garcía..................................
pol. ind. campo alto, parcela 46......
03600 elda, alicante - españa..........
tel 96 539 90 07 / fax 96 539 48 46
info@pedrogarcia.com...................
www.pedrogarcia.com....................
...
...
...
...
...
...
...
...

pedro garcía
elda, alicante/españa

pedro garcía /españa

The inspiration for the concept comes from the age-old
practice of shoemakers stamping their name on their
wares and, in addition to creating actual stamps, all of the
applications of this logo retain the look of a stamp. This idea
came to the designers fairly early in the process and so it was
only a matter of typesetting to arrive at a finished product.
The end result reflects a desire to present a sophisticated
brand without conceding anything in terms of readability and
visual power.

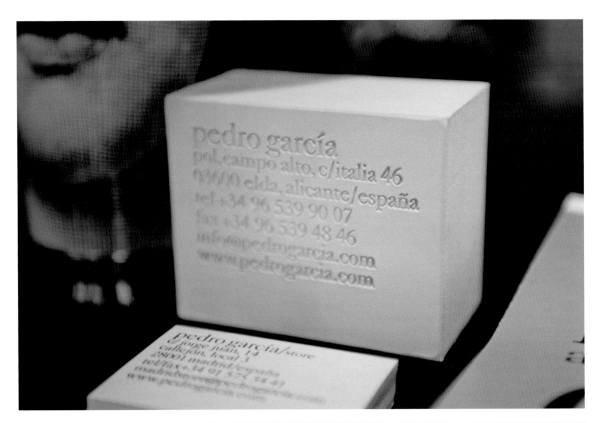

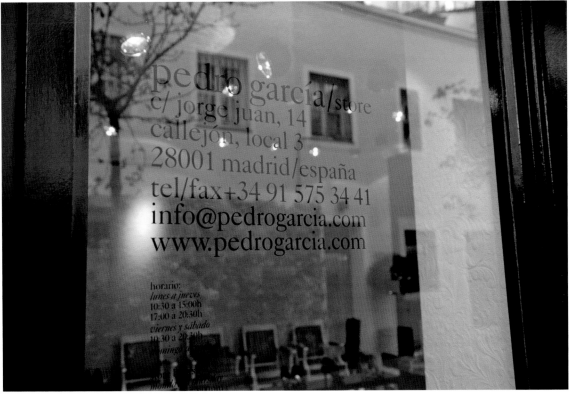

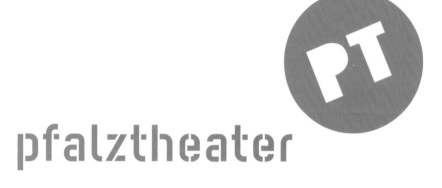

Pfalztheater

A circle, an abbreviation, the color red, and a typeface stencil come together to shape the suggestive logo for this theater in Kaiserslautern, Germany. The form derives from the idiosyncratic rounded architecture of Pfalztheater and also refers to the light of a reflector. Red is the color of the sandstone typical of the region, and the letters *PT* are an abbreviation of the name. The use of stencil incorporates a conceptual dimension: the theater as an intermediary and transitional space, indicated by the use of a typeface that might be seen on a carrying case or cargo crate.

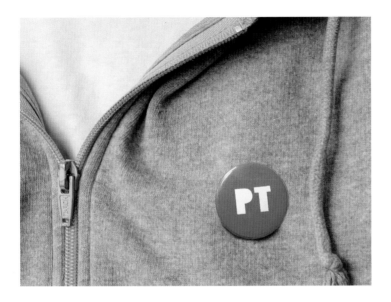

MAGMA Brand Design

MAGMA is a design agency with a focus on corporate and brand design, based in Karlsruhe, Germany.

www.magmabranddesign.de

Where did you draw inspiration from for this project?
The Pfalztheater logo was inspired by the theater's architecture and location, as well as by elements of its interior, such as spotlights, scenery, storage rooms, and the lettering on transport boxes.

What lessons have you learned about logo design or what do you wish you had known?
Not much.

What advice do you have for other designers?
We don't give advice to other designers.
To students: Context and appropriateness are everything—keep your eyes open to what's happening in visual culture, and be conscious of the significance and nature of clients, brands, institutions, and the general public.

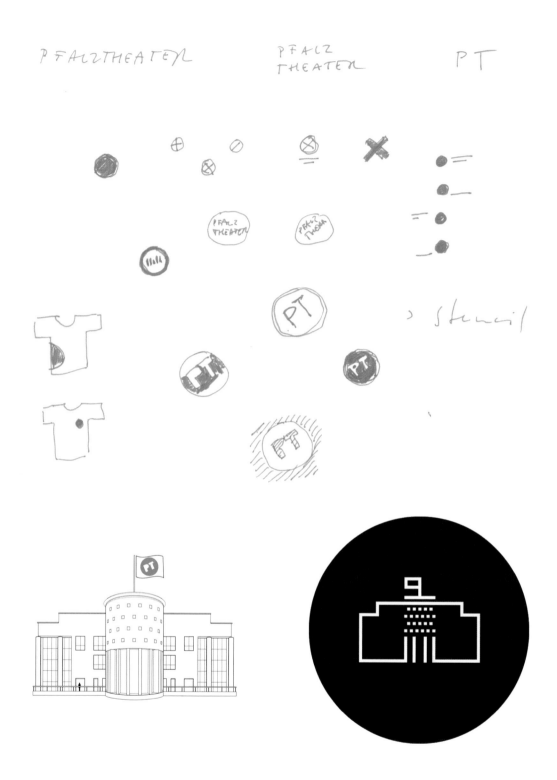

The most visible aspect of Pfalztheatre's building is a round tower which is echoed by the red orb of the logo. The logo clearly has any number of applications: a button, the emblem on a flag, the design for a t-shirt. The designers have created a versatile logo that will last the theater through a myriad of projects.

Poudre River
Public Library

Just like rivers, libraries are a source of renewal for their
communities, and a place where relationships form, trade
takes place, and information flows. This parallelism was the
most attractive theme that arose in the Toolbox brainstorming
session on the identity of the Poudre River Public Library in
Fort Collins. So, referencing the natural resources that connect
the diverse area where the library is located, they designed an
icon in which the superimposition of wavy lines in earth tones
suggests a river, the sedimentary layers of a mountain, and the
pages of an open book seen in profile.

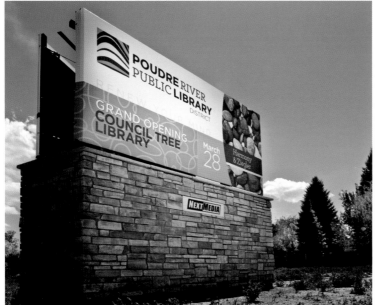

© Steve Glass and Harper Point Photography

Toolbox Creative

Toolbox Creative is a full-service design firm specializing in branding, based in Fort Collins, Colorado.

www.toolboxcreative.com

Where did you draw inspiration from for this project?
We work with many arts and cultural institutions, and quite often the biggest competition for people's attention comes from outdoor recreation. For the Poudre River Public Library name and identity, we embraced that competition head-on. Several themes kept rising to the top; most interestingly, the similarities between rivers and libraries.

What lessons have you learned about logo design or what do you wish you had known?
Over the years, we've learned a lot about working with committees. Large groups of people with divergent interests and strong opinions can pose a great challenge to good design. The key is to identify and engage every key influencer early on in the process. Logo design is an inclusive, but not democratic process. When logos are selected democratically by committees, we end up with everyone's third-favorite logo. No one loves it, but no one hates it.

What advice do you have for other designers?
Be passionate and take ownership in your work, but don't let your personal connection fog your judgement when presenting logos to a client. Always use an objective, scientific perspective.

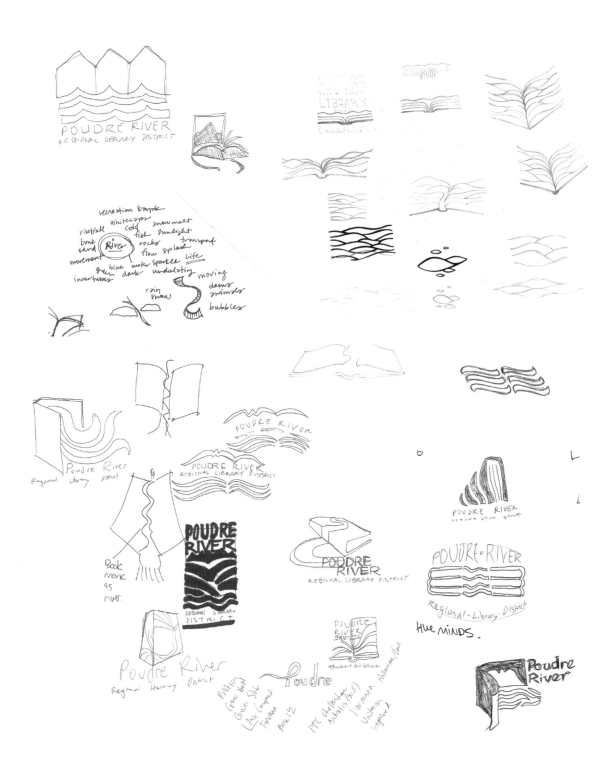

Toolbox began with pencil sketches attempting to literally draw lines between the river, which is a prominent feature in that part of Colorado, and the books housed in the new library. After narrowing the focus to the river concept, twelve ideas were reduced to three, which were then presented to the library's board of directors in order to adopt one.

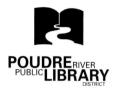

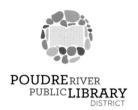

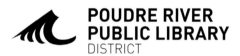

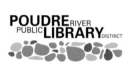

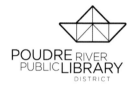

Proyecta Visual

For designer Laura Meseguer's work with Proyecta Visual, an audiovisual production company, she drew all of her proposals by hand until she found one that could easily be transferred to a vector for further development. As part of her work, Meseguer contributes to editorial projects and other design developments in which the use of typography is the main feature. Thus, in this case, she arrived at a new logo that satisfied the company's desires: dynamic, easy to read, and personal.

Laura Meseguer

Laura Meseguer is a graphic designer and type designer living and working in Barcelona.

www.laurameseguer.com

What is your personal design process?
Concept, design, and implementation.

What lessons have you learned about logo design or what do you wish you had known?
Through the design of logos, I've learned about simplicity.

What advice do you have for other designers?
For other designers: Explore intuition as a creative resource.

PROYECTA VISUAL

PROYECTA VISUAL

PROYECTA VISUAL

PROYECTA VISUAL

PROYECTA VISUAL

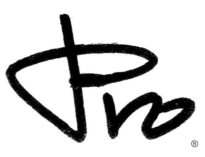

PROYECTA VISUAL

Pro was most interested in a logo that was direct, and conveyed the personal touch that they prize in their relationships with their customers. Meseguer's approach was just as direct: the logo should be created by hand, as if an employee of the company was signing off on an order.

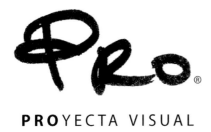

PROYECTA VISUAL

PROYECTA VISUAL

PROYECTA VISUAL

PROYECTA VISUAL

Rebekka
NOTKIN

Rebekka Notkin

For the re-launch of the atelier-boutique of Danish silversmith
Rebekka Notkin, ATWTP developed a logo that combines a
Courier Sans with an Apollo. They also designed an icon,
a hand-drawn emblem in which two bracelets are linked in a
movement of curves and simple textures. The hand-drawn
image is intended to convey the idea of careful craftsmanship,
while the aesthetic of the textual element communicates
sophistication and refinement. Everything in the new identity
is based on notions of manual dexterity, professional finishing,
and quality jewelry.

Bredgade 25
1260 Copenhagen K
+45 33 32 02 60

rebekkanotkin.com

ATWTP

ATWTP (All The Way To Paris) is a graphic design studio based in Copenhagen, Denmark.

www.allthewaytoparis.com

Where did you draw inspiration from for this project?
The Rebekka Notkin emblem was inspired primarily by her jewelery and her tone of voice, as well as by traditional symbols of craftsmen.

What lessons have you learned about logo design or what do you wish you had known?
Every logo is a new project. The logo has to represent the company or client and all that they are.

What advice do you have for other designers?
Always research and get to know the client very well. A logo should never be a decoration—a logo should communicate the core of the business, organization, or client. The logo should represent the owner of the logo.

Rebekka
NOTKIN

Rebekka
NOTKIN

Rebekka
NOTKIN

Rebekka
NOTKIN

Rebekka
NOTKIN

Rebekka
NOTKIN

While ATWTP's earlier proposals either manifested Rebekka Notkin's refined sensibility or her company's attention to craftsmanship, only the final design, which combines the image with the text, is able to present both characteristics. Further, the mix of typefaces with and without serifs shows off the brand's equal commitment to both classic and contemporary styles.

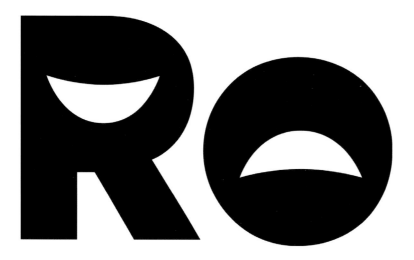

Ro Theatre

Classic theater masks, a graphical representation of tragedy and comedy, are expressed in the heavy, rounded body of the word Ro. The Ro Theatre is one of the three major theater companies in the Netherlands and is an institution essential to the cultural identity of the city of Rotterdam. As they did in their redesign for the International Film Festival Rotterdam, the 75B studio worked in black and white and created a resounding logo that becomes its own character—or two—and is deeply characteristic of the nature of the Ro Theater and theater itself.

75B

75B is a multi-designer graphic design and branding firm based in Rotterdam in the Netherlands.

www.75b.nl

What are the basic rules of logo design?
Our basic principles about logo design include the full confidence of the client and also visual vision rules.

Where did you draw inspiration from for this project?
Regarding this project for Ro Theatre, we were obviously inspired by cliché theater logo's.

What lessons have you learned about logo design or what do you wish you had known?
I wish I had known that it pays very little to design logos, except if you make middle-of-the-road ones.

Theater masks, yin and yang, and simple figures shape 75B's
quest for a somewhat crude, yet highly effective, typographical
sign. Many of these early characters attempted to merge the
R and O, thereby obscuring the company's name, while others
were deemed too silly or childish. The end product is the perfect
mix of child-like wonder, communicative power, and serious
incite—just like good theater.

Ruhr Museum

Ruhr Museum

The Ruhr region is the most populous urban area in Germany and the fourth-most in Europe. The European Capital of Culture in 2010, its history is marked by the evolution of coal, industry, and new technologies, as well as the topography of the Rivers Ruhr and Rhine. All of this had an influence on the Ruhr Museum logo designed by Uwe Loesch, in which there is a seismic graphical shift that refers to the changes in the region that has led to a massive influx of immigrants, among other things. The logo may also serve as a visual reminder of the museum building, the old coal-washing plant at the Zollverein mine in Essen, a UNESCO World Heritage site.

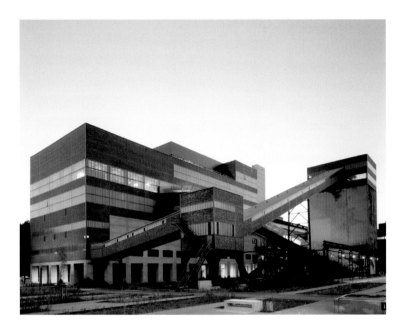

Uwe Loesch

Uwe Loesch is a graphic designer living and working in
Mettmann, Germany.

www.uweloesch.de

What is your personal design process?
It should be capable of being printed, without problems,
in both negative and positive, of being made extremely big
or very small, and should still be readable if it is rendered
unsharp. It should be applicable in all media. It should be
distinctive, unique, and easily learnable.

What lessons have you learned about logo design or what do
you wish you had known?
Follow the KISS principle:
Keep it simple, stupid.
Keep it simple and stupid.
Keep it small and simple.
Keep it sweet and simple.
Keep it simple and straightforward.
Keep it short and simple.
Keep it simple and smart.
Keep it strictly simple.
Keep it sober and significant.

What advice do you have for other designers?
No Logo!

In Loesch's earlier attempts, experimentation with different horizontal lines, especially in terms of thickness and weight, can be seen. Also evident is his interest in exposing the cross section, referencing the museum's building, the bricks of which are striated by long rows of windows stretching across its mass.

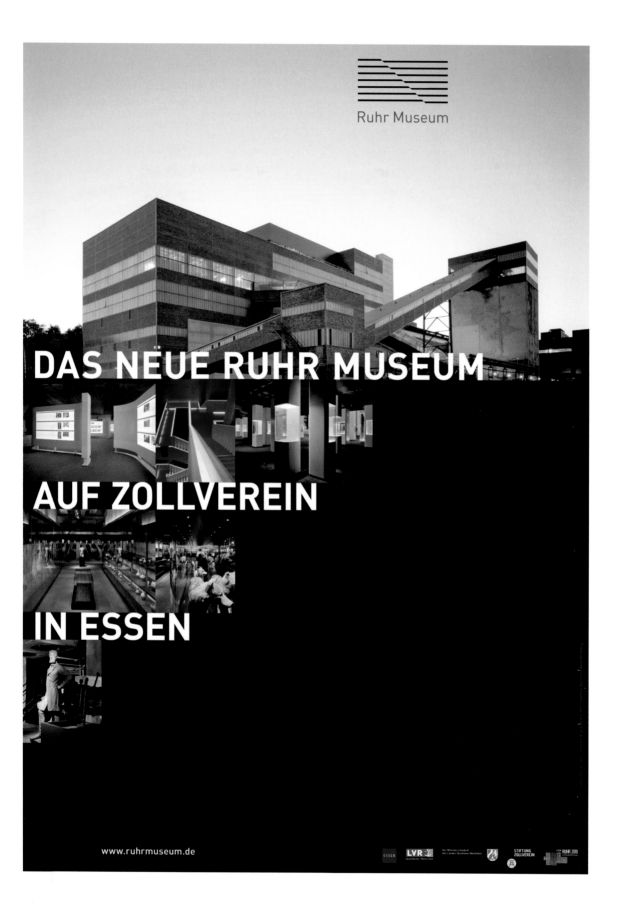

DAS NEUE RUHR MUSEUM

AUF ZOLLVEREIN

IN ESSEN

www.ruhrmuseum.de

SANDBERG INSTITUUT AMSTERDAM
MASTERS RIETVELD ACADEMIE

Sandberg Institute Amsterdam

Pinar Demirdag and Viola Renate, two young Dutch designers, were given the challenge of translating the body of work of their countryman William Sandberg, a well-regarded type designer and museum curator, into a logo for a new institute carrying his name. The visual image for the Sandberg Institute Amsterdam had to give a contemporary response to Sandberg's sensibility. To this end, the designers created a logo with an *Ad Hoc* font that combines roundness with unique, strangely pointed, sharp edges.

Pinar&Viola

Pinar&Viola is an Amsterdam-based graphic design company comprised of Pinar Demirdag and Viola Renate, specializing in what they describe as "ecstatic surface design."

www.pinar-viola.com

What are the basic rules of logo design?
We consider a logo really successful only if it becomes a character—a strong personality that does not remain a walk-on.

Where did you draw inspiration from for this project?
For the Sandberg Institute Amsterdam, Masters Rietveld Academie, we were inspired by the tactility of different paper combinations in (typographer and museum curator) Willem Sandberg's work, as well as by old school artist portfolio patterns, paper marbling, and students from the globalized world. We were even inspired by the theory of a fourth dimension.

What advice do you have for other designers?
In order to obtain a genuine and charismatic character for a logo, designers should put the focus on the authenticity of the ingredients that they use.

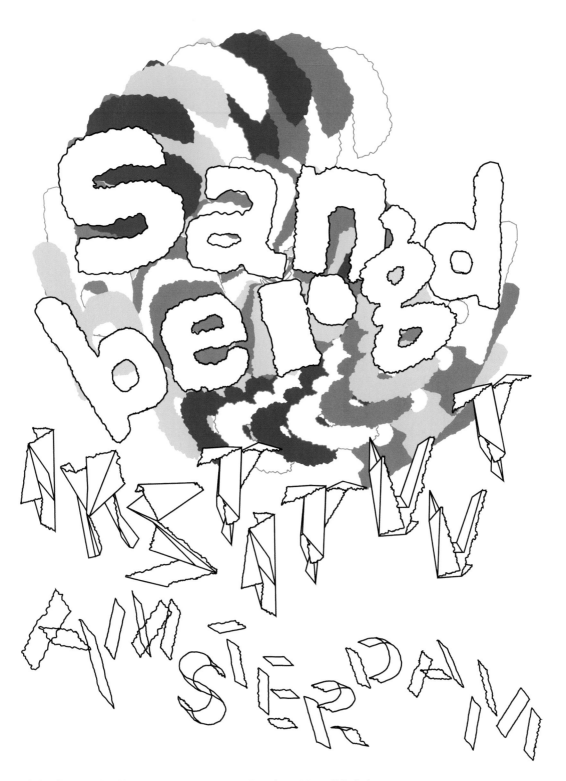

While the finished logo is more conservative than Pinar&Viola's first attempts, it is capable of communicating the stability and insight of the institution while still expressing something of Sandberg's own distinctive voice. The discarded efforts attempted to more closely match Sandberg's style, but were considered too busy or even reductive. The designers parried by creating their own typeface, as Sandberg might have done, that combines shades of *Equipoize Sans*, *Bell Gothic*, and *Domestos*.

SANDBERG INSTITUUT AMSTERDAM

Masters
Rietveld Academie

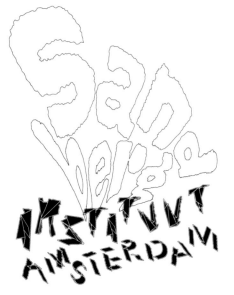

AANA DDB
MM MA TTT D
S TN BBE EER
MN G RR
G GG GG G
BERG

SANDBERG INSTITUUT AMSTERDAM
Masters Rietveld Academie

SANDBERG INSTITUUT AMSTERDAM

SANDBERG INSTITUUT AMSTERDAM

A→A T→T U→U

sa nd be rg

SCULPTURE INTERNATIONAL ROTTERDAM

Sculpture International Rotterdam

Sculpture International Rotterdam was created to preserve and extend the outstanding collection of public sculpture in the Dutch city. From the outset, the institution's aim was to protect the sculptural legacy of the city and give rise to a new public art scene. Therefore, their new identity needed to convey a sense of the past, present, and future of public art in the shared space of urban Rotterdam. Dutch firm 75B took charge, exploring typography in terms of sculpture by investigating the volume, movement, and materiality of letters.

75B

75B is a multi-designer graphic design and branding firm based in Rotterdam in the Netherlands.

www.75b.nl

What is your personal design process?
We just think of ideas, and then sketch some things in a notebook. We normally don't touch a computer until we think we have a good idea. Our focus is always on the communicative power of an image.

Where did you draw inspiration from for this project?
For Sculpture International Rotterdam, we were inspired by classic sculptors and what they do with their materials.

SCULPTURE INTERNATIONAL ROTTERDAM

SCULPTURE INTERNATIONAL ROTTERDAM

SCULPTURE INTERNATIONAL ROTTERDAM

SCULPTURE INTERNATIONAL ROTTERDAM

SCULPTURE INTERNATIONAL ROTTERDAM

SCULPTURE INTERNATIONAL ROTTERDAM

SCULPTURE INTERNATIONAL ROTTERDAM

75B was interested in investigating typesetting through sculpture and immediately set out drafting a variety of logos that gave new shape to the forms of the words of Sculpture International Rotterdam and its constitutive letters. After constructing a number of logos which reshaped the words as sculptures, they and the client realized that creating a new type set would allow for each word of a given title or exhibition name to possess its own organic shape and style, and would therefore be able to extend their brand even as they sought to extend the life and value of public art and sculpture in Rotterdam.

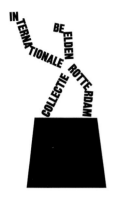

SCULPTURE INTERNATIONAL COLLECTION ROTTERDAM

SCULPTURE
INTERNATIONAL
ROTTERDAM

SCULPURE
INTERNATIONAL
ROTTERDAM

B E INTERNATIONALE COLLECTIE ROTTERDAM E N

B E INTERNATIONALE E COLLECTIE D ROTTERDAM N

INTERNATIONALE BEELDEN COLLECTIE ROTTERDAM

SCULPTURE
INTERNATIONAL
ROTTERDAM

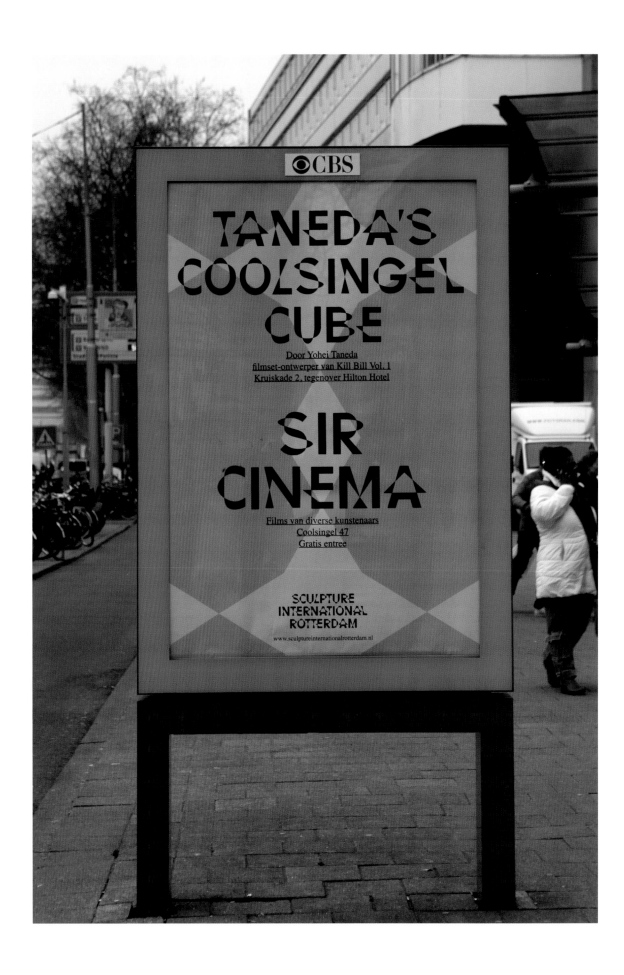

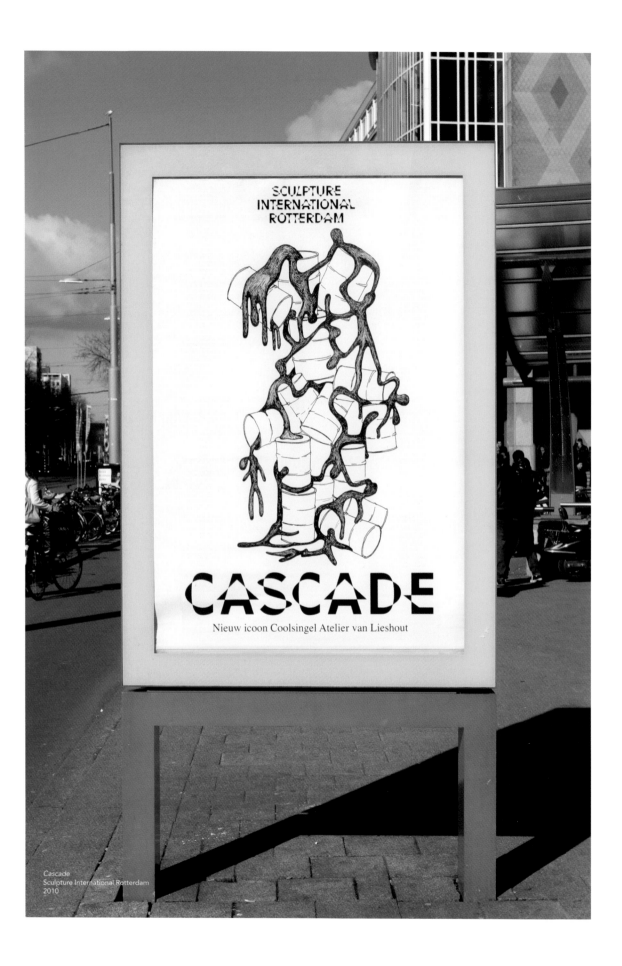

SCULPTURE
INTERNATIONAL
ROTTERDAM

CASCADE

Nieuw icoon Coolsingel Atelier van Lieshout

Cascade
Sculpture International Rotterdam
2010

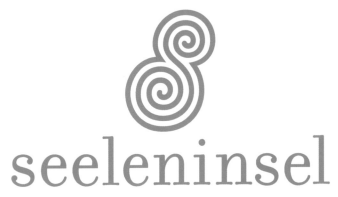

seeleninsel

Praxis für Logopädie und Psychotherapie

Seeleninsel

Seeleninsel means "island of the soul" in German and is the name of a medical consultancy that offers dialogue and psychotherapy services. Following his usual process, Claudius started with hand sketches that were pure intuition, making doodles with the letter S. This graphic concept originated from the symbol of infinity and is also a recognized motif in jewelry, especially in rings, where a silver thread forms a simple spiral. The immediacy of these recognizable elements makes the final icon alluring.

Claudius Design

Claudius Design is a graphic design firm based in Essen, Germany, led by Stefan Claudius.

www.claudius-design.de

What is your personal design process?
I start by asking questions and trying to figure out what kind of person the client is. Understanding who he or she is and what he or she really wants is the basic task. It makes you feel like a psychologist. In my opinion, the logo should be a kind of portrait of the client or the enterprise. Then comes the practical part of scribbling and sketching. I start drawing even if I have no precise idea. Then I start with Illustrator, because I need to see the clarity of the lines. The client receives three logos, and the winner is refined until it is good.

Where did you draw inspiration from for this project?
There is some sort of silver jewelry, a silver wire rolled to discs, which looks marvellous. And I constantly thought of the infinity symbol. These two ideas, mixed together, lead to the logo.

What advice do you have for other designers?
I have a lot of advice for my students, but I am not sure if I have any for other designers, because I think diversity is very important. Just one thing: Keep on trying. Don't be satisfied or disappointed with your first sketches, and don't produce visual pollution, please.

Claudius' concept for the Seeleninsel project never strayed far from variations on an ornate S. From his original doodles and two divergent concepts—the shape of a particular piece of jewelry and the infinity sign—he crafted a logo full of immediacy and spark, and finished it off by coloring it in a subdued, yet stately, teal.

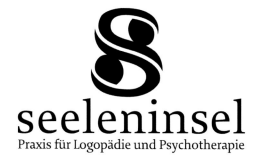

seeleninsel
Praxis für Logopädie und Psychotherapie

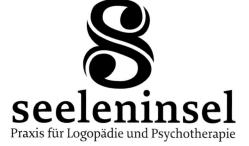

seeleninsel
Praxis für Logopädie und Psychotherapie

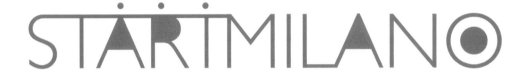

Start Milan

For Start Milan, Artroom chose a *Gill Sans Light* and subjected
it to all kinds of modification—some subtle, some less so. In
the logo, the arms of the *S* and *T* are joined together, while
in the applications, the words Start Milano are doubled and
redoubled until a graphic pattern with an interesting geometry
manifests itself. This visual echo effect references the network
of galleries that identifies the brand: thirty-seven galleries in
Milan that inaugurate their exhibitions simultaneously.

Artroom

Artroom is the name of the full-service design, branding, and illustration company headed by Sergio Calatroni, based in Milan.

www.sergiocalatroni.com

Where did you draw inspiration from for this project?
For Start Milano, we wanted to keep the logo very simple, but with a special touch. So, in order to give this project a kind of spice, we were inspired by the decorative accents we observed in Scandinavian or Hindi letters.

What lessons have you learned about logo design or what do you wish you had known?
The research might come from the everyday, breaking the border between work and pleasure—so, you get inspired from each moment of your life. Regarding simplicity: We need to keep it simple so that the visual impact is strong and pure. Also, to have simplicity helps you trasmit your idea without any obstacles. Finally, a lot of time is required to understand originality. You can't say, "I made an original thing." The real original lasts in time, and will always remain fresh.

STARTMILANO
STARTMILANO
STARTMILANO
STARTMILANO

STARTMILANO
STARTMILANO
STARTMILANO

STARTMILANO
STARTMILANO
STARTMILANO
STARTMILANO

START

START
MILANO

START
MILANO

START
MILANO

START
MILANO

Gill Sans is a well-known font family, well regarded for its imminent readability and its pliability in use for both text copy and for titles and displays, but, with a few artful touches by Artroom, it becomes transformed into something whimsical and almost otherworldly. Here, Artroom combines vibrant color and playful ornamentation with a classic typeface and a robust concept to create a logo that communicates innovation as well as timelessness.

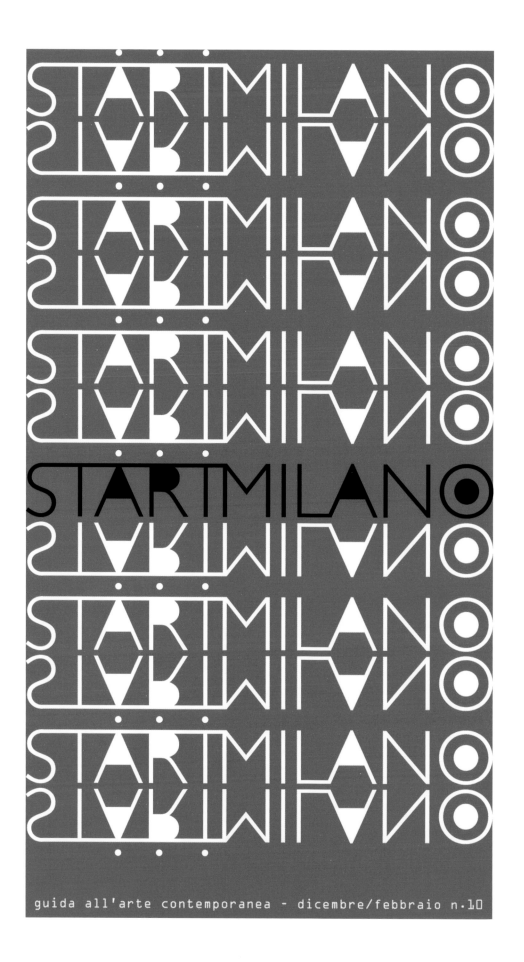

STARTMILANO

guida all'arte contemporanea - dicembre/febbraio n.10

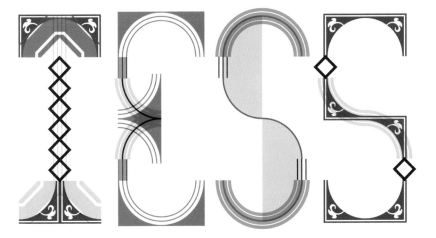

TESS

For the design of the identity of the modeling agency TESS
Management, the London studio Mind Design displayed its
love of decoration and ornaments, as it had in other recent
projects. The plentiful variations of the logo, arranged in a
modular system, are inspired by Art Deco but with a distinctive
contemporary edge. In other printed applications where
additional visual concepts from the sixties are adopted,
the same 1930s influenced ornaments are used to frame
photographs of the agency's models, as can be seen on their
website for instance.

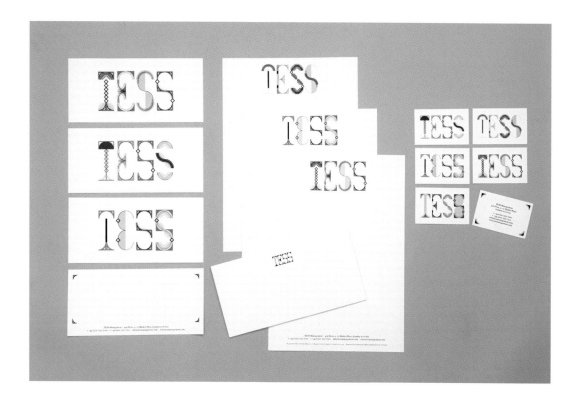

Mind Design

In collaboration with Simon Egli, Zurich

Mind Design is an independent London-based graphic design
studio founded in 1999 by RCA graduate Holger Jacobs. Mind
Design focuses on integrated design which combines corporate
identity, print, web, and interior design.

www.minddesign.co.uk

What are the basic rules of logo design?
We consider how the logo will be used and who will
implement it. A design for a big international company
should be more structured, whereas a design for a local
company, which we would implement ourselves, can be more
playful and experimental.

Where did you draw inspiration from for this project?
TESS and Circus are both inspired by elements of Art Deco,
a style I am very interested in recently. TESS is a modeling
agency run by strong women. Its name comes from the
combined initials of the owners and relates to the novel
Tess of the d'Urbervilles. The design for TESS is certainly
an attempt to get away from Modernist design, which
influenced our work for quite a while. I would call it Art
Deco—flower power—Modular Constructivism.

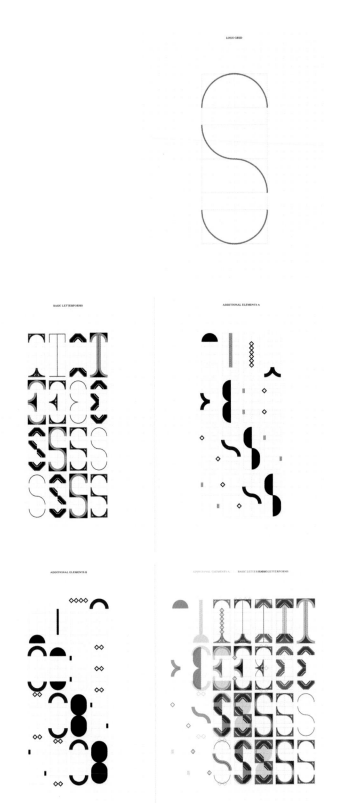

The basic form of the letters comes from a grid of squares and
rectangles that also creates the ornaments, grouped into sets
of *A* and *B*. The quantity and density of the decorative elements
allow for a variety of logos, ranging from dense and colorful, to
delicate and airy.

CMYK	RGB	PANTONE No.

Times Ten LT Std sept

ABCDEFGHIJKL
MNOPQRSTU
VWXYZ[Ææß@&
§‡«»%€£$]abcdef
ghijklmnopqrstuvw
xyz0123456789©®
!?;.···

TESS TESS TESS

TESS TESS

TESS
TESS
TESS

TESS
TESS
TESS

TESS
TESS
TESS

TESS
TESS
TESS

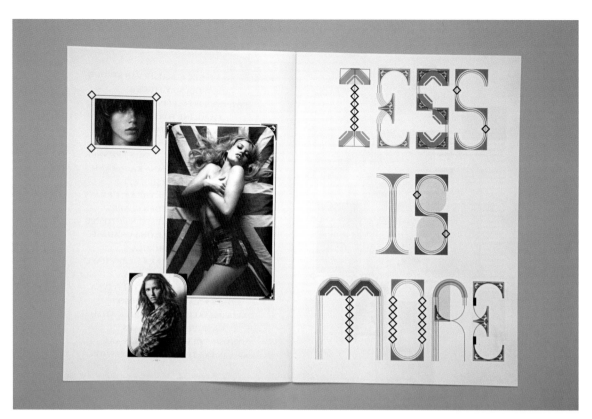

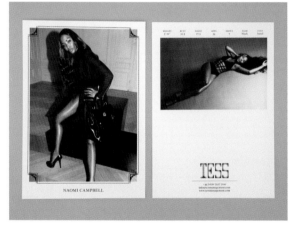

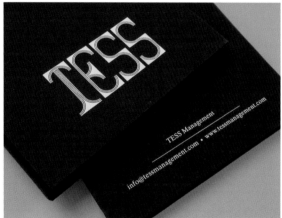

The See

The one hundred and sixty logos that the London-based Danish designer Kenn Munk designed for his project *The See* are the result of a combination of two fixed and one variable element. The typography of the name remains, as well as the perimeter of the circle that encloses it. It is the treatment of the circle that differentiates each of them. The theme of the project was the changes that take place in look and perception due to a change in the circumstances of the observer. Thus, these one hundred and sixty stamps are actually a single logo with multiple but curiously boundless personalities.

Kenn Munk

Kenn Munk is a Danish graphic designer, topographer, and toy
maker based in London.

www.kennmunk.com

What is your personal design process?
It starts with a lot of questions. We need to determine if
what we learned about the client and the product is the
truth—some of the questions we ask clients can prompt
obvious "right" answers. Then we start the visual research
and sketching.

Where did you draw inspiration from for this project?
It was almost a stream of consciousness. *The See* is about
how our culture has imprinted patterns, or "key" images,
onto our brains. The inspiration came from all the things
that I know would get a second look from me if I spotted
them somewhere—everything from color-blindness tests to
honeycomb patterns, to World War I dazzle camouflage.

What lessons have you learned about logo design or what do
you wish you had known?
I was taught that a logo must be designed—or at least
delivered—in Illustrator format, that it has to survive a series
of tests: does it work in black and white, in negative, is it too
small? I want to work against that kind of thinking soon.

STAMPS?

The Naiad.
Nymphs of The Surface
Overfladens Nymfer
wellcome to superficial
Superficial PYNTET
VELKOMMEN TIL OV ERFLADEN

THANKS!

MOM
portori
KNOI
Presse - koncept

正宗川菜燒烤

SHELL MOUNTAINS
Fotora BlackLetter

FAKE POSTCARD
FAKE TOURISM

UDSTILLING
V+A/ + Volumen.
BV: drik...ikke.
Jeg er ikke
kendt+
nok+

Hvem kommer?
Venner, familie
elever,
Hvem vil jeg have
presse, evt. kunde

PRESS:
2 MÅL: Private View /Book
Lokale, Regionale rfagmedier
Dæk udstilling engengen
1 MÅL: Få besøg til udstilling
Direct mail kampagne til medier
404.dk, århus onsdag, gratis Aviser
Dansk Dynamit - plakater, Aarhus.dk
3 MÅL: International anerkendelse/dækning

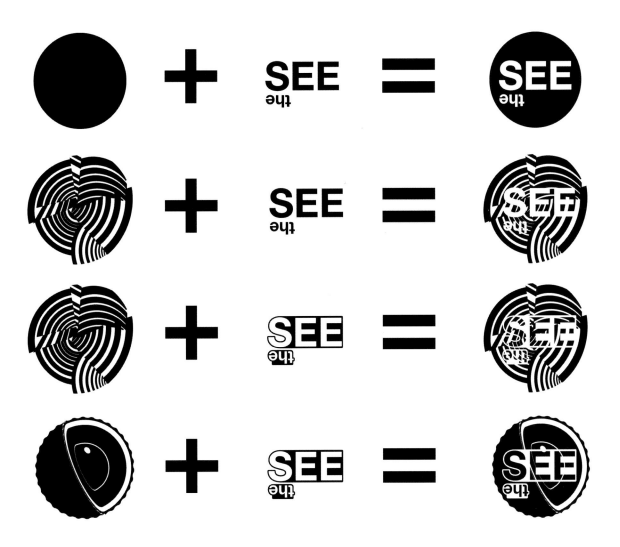

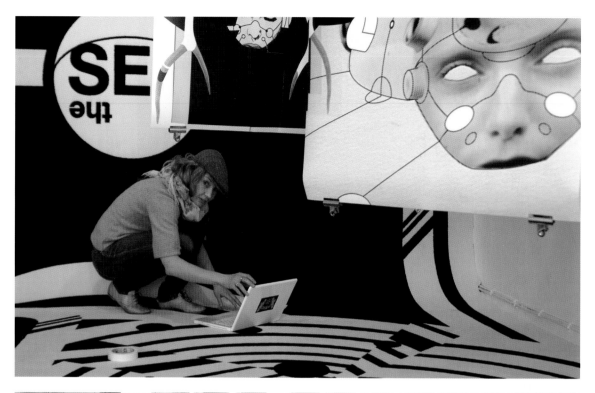

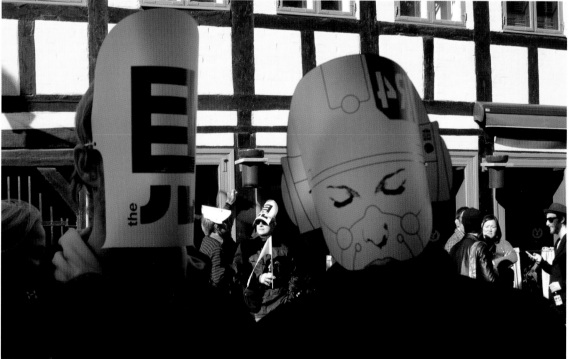

Scientific diagrams, optical illusions, industrial brands,
color tests, and space travel were all inspiration for Munk's
cosmology of logos. Indeed, his product seems to be the
process itself—as much was kept as was discarded. The
simplicity of the form of the circle and the name rendered in a
very stable *Helvetica Neue Bold* made it possible to manipulate
other aspects of the logos' frames.

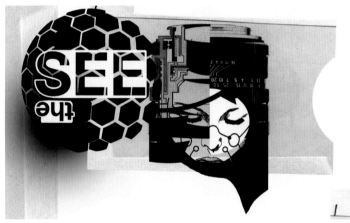

LYNfabrikken præsenterer:
Kenn Munk: The See

Kom til fest + fernisering
Fredag d. 3 april fra 16:00

Udstillingsperiode: 3-29 april 2009
www.lynfabrikken.dk

LYNfabrikkens BOX
Vestergade 49 8000 Århus C

THE TONE TRAVELLERS

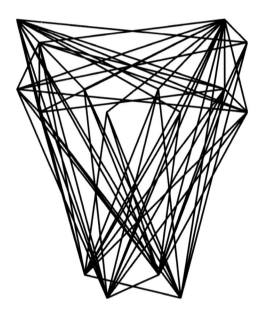

The Tone Travellers

In poetry, alliteration—the repetition of primary sounds—is an exciting and powerful aural device. Its visual analogue is the tautogram—the repetition of primary letters. In the case of The Tone Travellers, a young jazz band from Amsterdam, there are three *T*'s that gave the designer Florian Mewes something to play with. The name, with its connotation of journeying through various musical styles, was the inspiration for the many bifurcating lines in the logo that suggest a plethora of past or future paths. A large, three-dimensional *T* and straight lines between their edges form a brand with enormous graphic potential for a dynamic identity. This design can be seen in the album jacket and posters.

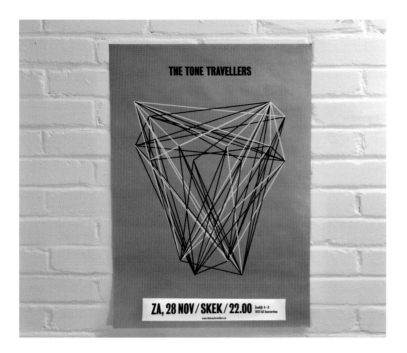

Florian Mewes

Originally from Berlin, Germany, Florian Mewes is a graphic designer living and working in Amsterdam. In 2001, he teamed up with Dutch designer Arjan Groot to form Groot/Mewes, a firm specializing in conceptually rigorous yet accessible design.

www.grootmewes.com

Where did you draw inspiration from for this project?
The inspiration for the Tone Travellers was the *T* and the idea of connecting points, which I find in the—sometimes even mathematical—way of improvising in jazz music.

What lessons have you learned about logo design or what do you wish you had known?
Since the idea is very strong in my design, I often tend to show sketches in a quite early stage to my clients, assuming that they can imagine how the fully worked-out version will look, even though they are not designers. But often they reject an idea, only to wind up loving it after I work it out in detail.

What advice do you have for other designers?
Look at other designs in your free time or on your holidays as often as you can, but put them away when starting your own work.

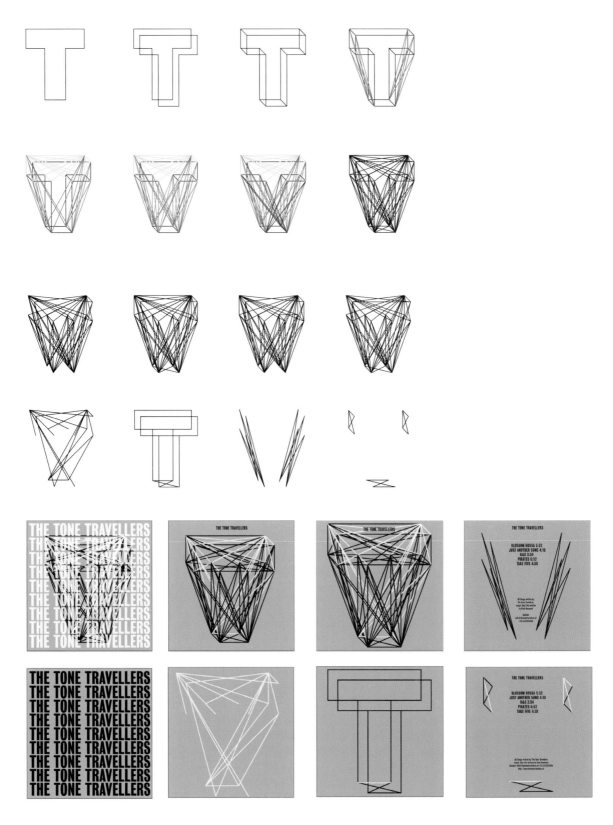

Mewes process was to tease the three *T*'s, allowing them varying degrees of significance in his early designs, before finally obscuring them—not altogether, but nearly. The route of this geometric, musically inspired trip draws a three-dimensional object resembling a diamond and concealing the *T*'s.

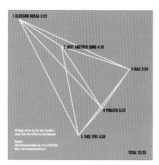

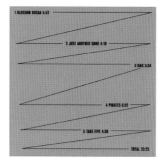

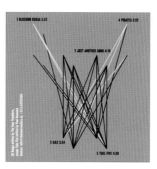

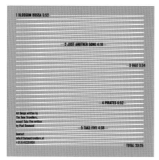

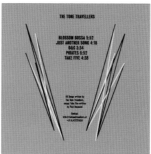

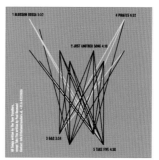

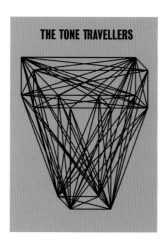

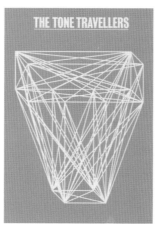

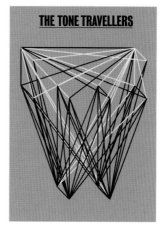

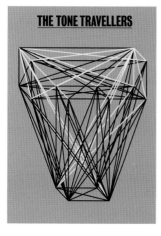

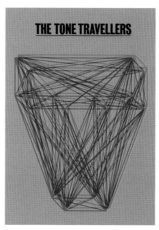

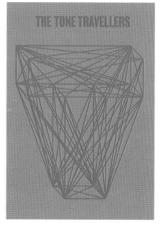

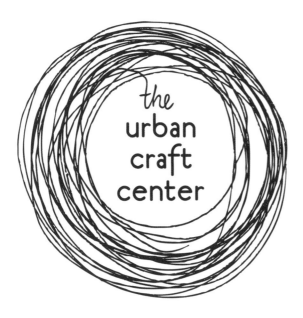

The Urban Craft Center

The Urban Craft Center, located in Santa Monica, California
is a meeting place where handicraft courses are taught. For
this reason, Also Design stepped away from the computer
and began to draw tools and hands based on the company's
name. But, these emerged in a comic-book style, which did not
convince them, so, they started again, and came up with the
circle, a visual metaphor for the idea of a "center." A nest of
string wraps around the name and untwirls to create the first
word of the name before giving way to a typeface originally
taken from a German handwriting manual from the 1920s, the
rounded *P22 Platten.*

Also

Also is a three person design company located in two cities: Matt Lamothe and Jenny Volvovski in Chicago, and Julia Rothman in New York.

www.also-online.com

What is your personal design process?
Initially, we collect visual and abstract ideas based on the company's name or field. We gather all these loose ideas and start to make really rough drawings of logos, mostly seeing if it works as a basic visual idea, before taking it any further. This helps us put together ten to twenty different ideas really quickly, without getting too attached to any one design. We work in a group, and this way of collaborating brings about a lot of different visual styles.

Where did you draw inspiration from for this project?
The process for this logo included a great deal of rounds and revisions. Initially, they had expressed a desire to have a comic-book reference in it.

What lessons have you learned about logo design or what do you wish you had known?
It seems as though color is becoming more important and reliable in logo design. As printing has moved away from black and white, and with more people viewing things digitally, color can be used as another element in a logo. However, starting in black and white is often a great way to see if things such as the silhouette and legibility are strong. If it doesn't work in black and white, then there's a good chance it's not going to work in color.

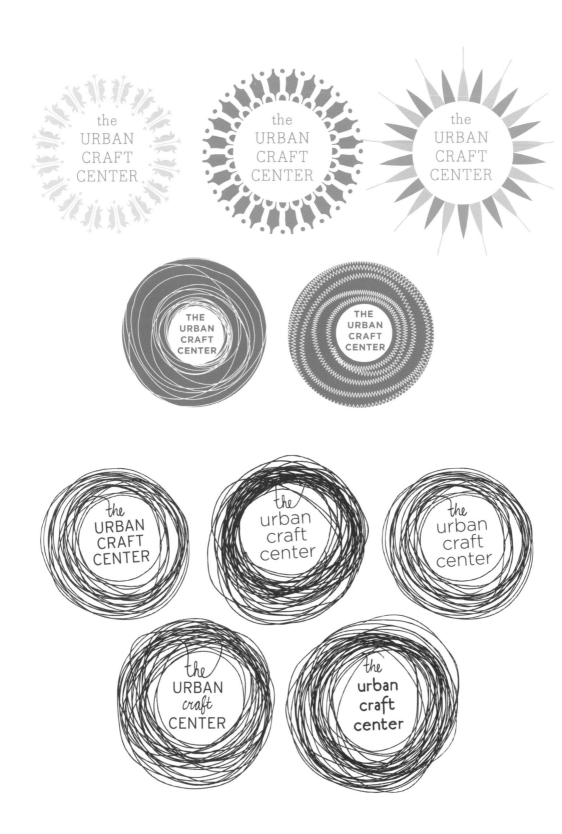

While Also's initial cartoonish illustrations of the tools of the Urban Craft Center were overlooked for the organization's main logo, they came back into play to spruce up and add depth and character to their website

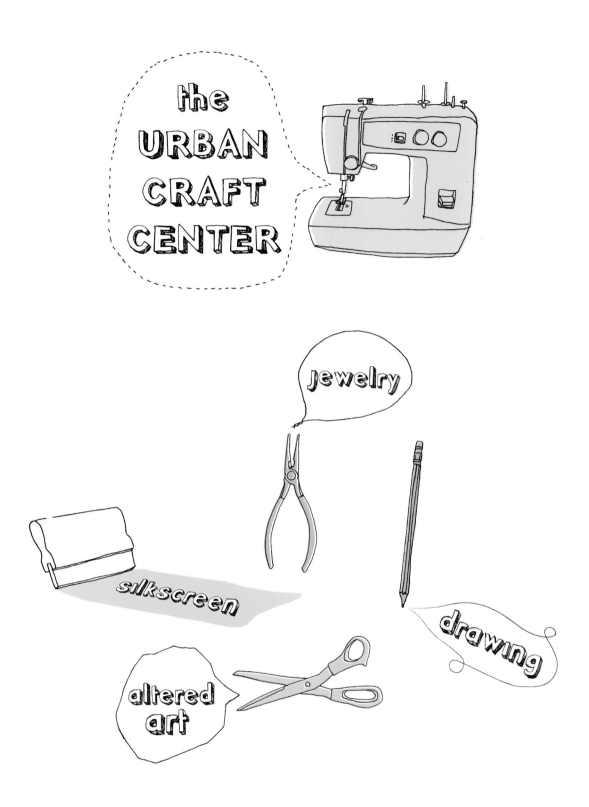

TIJDELIJK MUSEUM AMSTERDAM 7-12 MEI 2008

Tijdelijk Museum Amsterdam

Once a year, the city of Amsterdam and the most important art institutions unite as the Tijdelijk Museum Amsterdam, a temporary museum that has run parallel to the annual fair Art Amsterdam, since 2006. The event, which has no walls, required assistance from the design studio of Annelys de Vet to establish connections between the usually separate institutions, and make the imaginary real. The facades of Tijdelijk Museum Amsterdam as the temporary headquarters were transformed by hand-painted white lines. These same lines extend across the event programs, maps, and logo. The stencil typeface *Adam* is a design by the typographer Anton Koovit, and further underscores the temporary nature of the event.

Studio Annelys de Vet

In collaboration with Rianne Petter (2008)

Studio Annelys de Vet is a graphic design company based in Brussels and Amsterdam.

www.annelysdevet.nl

Sandberg Institute Amsterdam (2009)

The Sandberg Institute is the Master's Program of the Gerrit Rietveld Academy, and offers postgraduate degrees in Fine Arts, Applied Arts, Design, and Interior Architecture.

What are the basic rules of logo design?
Although it might sound cheeky, the rule is to avoid rules. In order to get a good representation of an organization or initiative, one has to understand the complexity of the story that needs to be told. Therefore the designer has to be open, without preconceptions or rules. It's about finding a shared mentality concerning the people, the meaning, the context, and, finally, the design. The form is the visual conclusion of this attitude, a total package in a wider context.

What is your personal design process?
Researching by designing, and designing by researching.

Where did you draw inspiration from for this project?
For the temporary museum, I compiled a wide list of references, varying from art performances in public spaces; to window screens of vegetable shops, with their cheaper product mentioned in wide chalk paint; to all different kinds of designs for maps and mapping systems.

TIJDELIJK
MUSEUM
AMSTERDAM

TIJDELIJK
MUSEUM
AMSTERDAM

TIJDELIJK
MUSEUM
AMSTERDAM

TIJDELIJK
MUSEUM
AMSTERDAM

TIJDELIJK MUSEUM AMSTERDAM
3–7 MEI 2006

Through horizontal lines, the graphic identity gives the event, disseminated through space, significance. In the spirit of the event, the process for the creation of this identity was a dynamic collaboration between the professional designers at Studio Annelys de Vet, the design students at the Sandberg Institute Amsterdam, and freelance designer Rianne Petter.

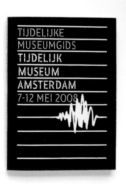

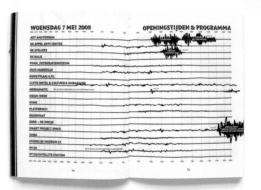

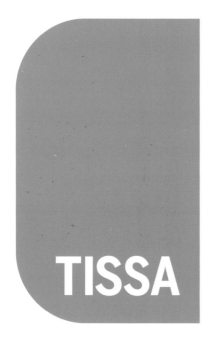

Tissa

The redesign of the identity of Tissa furniture was meant
to reflect the changes in its business. Tissa began by
manufacturing furniture made from metals and moved on
to specialize in office furniture and filing cabinets. The new
identity needed to attain a kind of plasticity in order to speak
to specific values of the brand, such as quality, modernity and,
most importantly, order. The designers, therefore, opted for
the powerful visual and practical appeal of a thumb tab index.
Synthetic and attractive, the thumb index invites the user to
browse a folder according to its contents, and, as an icon, it
serves as a visual analogy for the exploration of physical space
and the functionality of furniture.

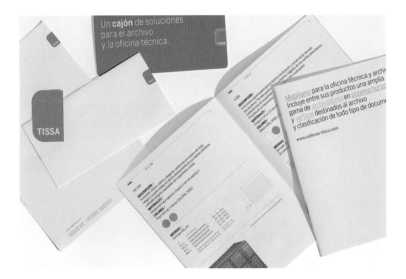

BAG Disseny

BAG is a design studio founded by Xavier Mora and Sandra Compt in 2002. The studio is based in Barcelona, Andorra, and Girona, and specializes in finding new forms of visual communication.

www.bagdisseny.com

What are the basic rules of logo design?
Extensive research is required for good results. You must know the target sector, how it works, what does not work, what has been done and why, what cannot be done, where the boundaries are, and how they can be addressed. In any project, research lays the groundwork for its development.

What is your personal design process?
In any project, it is important to enjoy a relaxed and predisposed relationship with our work. This requires listening to, and understanding, the customers needs and concerns. Usually it is at this stage of the project, before we have started, that we can guess if the red alert light will turn on a lot. If this happens, two things may occur: We continue with the project, as there is a glimpse of good vibes; or we stop right there, and the project is no more.

What lessons have you learned about logo design or what do you wish you had known?
Attaining simplicity is like learning how to remove all the petals from a flower without it ceasing to be a flower. It is long and complicated process, but it yields great results.

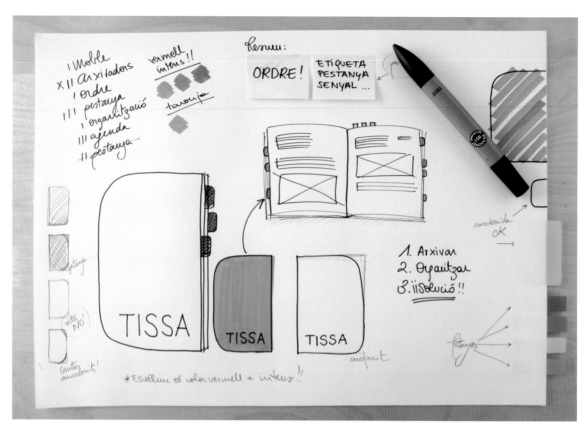

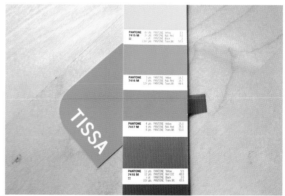

The designers had fun organizing and reorganizing their ideas
using post-it notes, stickies, and tabs, before hitting on the
exact right system to bring order to their once-chaotic thinking.

Mobiliario para la oficina técnica y archivo.
Incluye entre sus productos una amplia
gama de archivadores en sistema horizontal
y vertical destinados al archivo
y clasificación de todo tipo de documentos.

www.salleras-tissa.com

TISSA

VORTEX

Vortex

Vortex is a company that offers an online wind-modeling service for wind industry professionals. In 2009, it asked Ummocrono to redesign their brand while maintaining the significance of the letter O in the Vortex name, a holdover from previous logos. But research revealed that a leading brand in the industry was already using the same concept. So Ummocrono turned instead to the definition of a vortex: a whirling mass of water or air that pulls everything to the center. The final logo is a step away from the more common environmentally-themed branding in the industry, to communicating the deep technological roots of the company.

Ummocrono

Ummocrono is a Barcelona-based cross-media design and branding company.

www.ummocrono.com

What are the basic rules of logo design?
It's important to always keep in mind the brief—the identified needs of the client. It's also equally important that the client understands and values your work.

What advice do you have for other designers?
Nina Wollner: Take away the unimportant. Make sure you get properly paid for your work.
Fredrik Jönsson: If you believe in a solution, stand up and argue for it. Don't give in too easily.

VΩRTEX

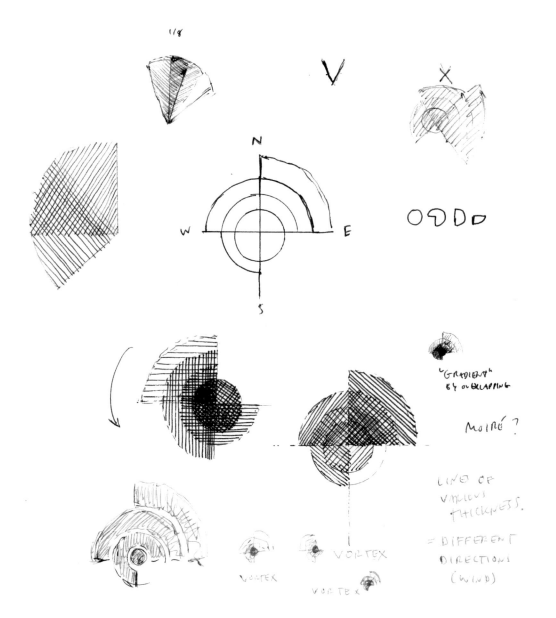

"GRADIENT" BY OVERLAPPING

MOIRÉ ?

LINE OF VARIOUS THICKNESS.

= DIFFERENT DIRECTIONS (WIND)

VORTEX

VORTEX

VORTEX

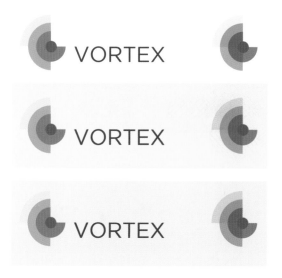

VORTEX → Gotham Book Regular

VORTEX → Gotham Light Regular

VORTEX → Caecilia Roman, Small Caps

VORTEX → Apex Serif Book Small Caps

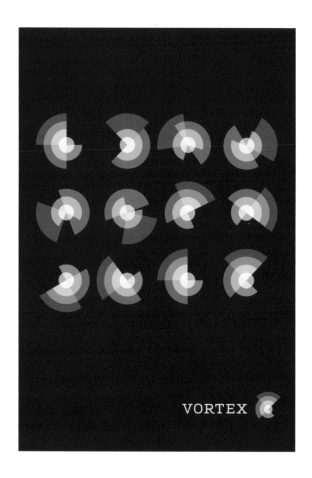

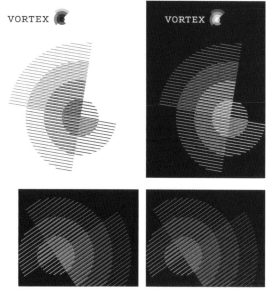

MAPS **MAST** **FARM** **FUTURE**

Working from photographic images of violent vortexes and from the idea of a wind rose (the often beautifully illustrated image showing various directional points on a compass, map, or nautical chart), the designers eventually came to a more abstract representation of their ideas, which both represented the company in the field, and set them apart from their competitors.

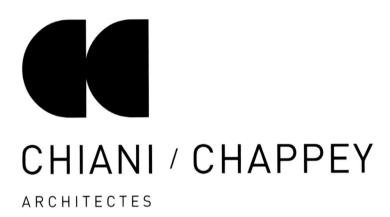

Walter Chiani and
Cedric Chappey

Walter Chiani and Cedric Chappey are architects in Lille, France,
for whom Les produits de l'épicerie designed a typographical
icon using their paired initials. Here, the *C*'s are on the brink of
legibility. They are, in fact, heavy figures, somewhat fuller than
a semicircle, and when repeated without changing their shape
or position the doubling achieves visual heft and materiality.
Les produits de l'épicerie is particularly interested in structures
and volumes, and regularly collaborates on graphic arts and
architecture projects.

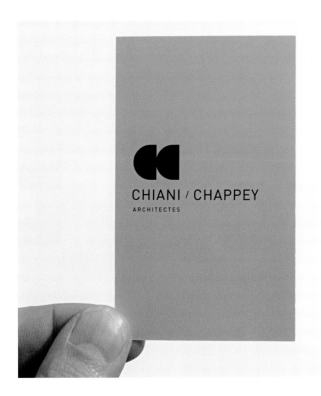

Les produits de l'épicerie

Les produits de l'épicerie is a graphic design studio in Lille, France founded by Philippe Delforge and Jérôme Grimbert, specializing in design for the cultural field: the performing arts, visual arts, music, and architecture.

www.lesproduitsdelepicerie.org

What are the basic rules of logo design?
We are very much interested in designing logos that are much more typogram than illustration. We can create many sensations, games, and structures by using only type. Typography has the capability of transforming into a sign even if the reading is difficult.

What is your personal design process?
First, making sure the client request is understood and trying not to answer too far beyond those bounds—that is to say, enlarging the request. Then making a lot of very trashy sketches on paper until one, two, or three decent ideas appear. Then translating these ideas into Adobe Illustrator. And, finally, the most important task is to remove all of that which is useless.

What advice do you have for other designers?
Our advice for other designers would be: Try to find the good combination between thinking and feeling.

In the finished marketing piece for Chiani/Chappey, the designer used a curry yellow color and flat finish work as a counterpoint to the sternness of the logo, thereby pushing it to the top of the viewer's attention.

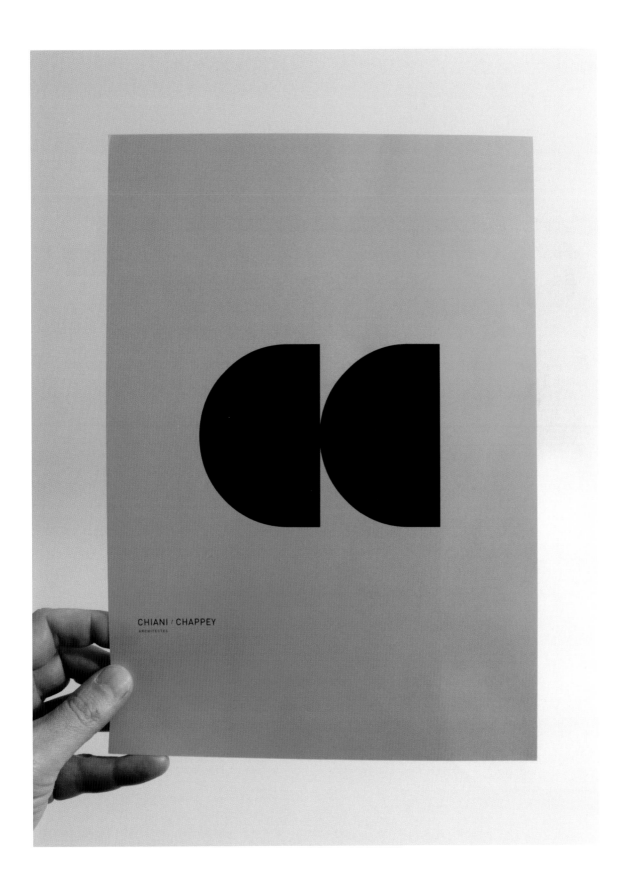

CHIANI / CHAPPEY
ARCHITECTES

ZeroCarbonCity
Reacting to Climate Change
Increasing awareness, reducing emissions.

ZeroCarbonCity

A circle surrounding two semicircles is also a zero that contains two letters C's. This was Intro's economical solution when designing the logo for ZeroCarbonCity, the global campaign conducted by the British Council in 2005 and 2006 to raise awareness about climate change, and measures that citizens can take. The name and the slogan(s) receive identical typographical treatment and, ultimately, impose an order which suggests the problem is containable. Only the color marks the territories. Thus, the logo is established without restraint while paying tribute to the political propaganda of the seventies. Pure twenty-first century activism.

Intro

Intro is a London-based design company that built its reputation on award-winning work for the music industry but has now branched out to include a much broader client base.

www.introwebsite.com

What are the basic rules of logo design?
How can I meet the brief as succinctly as possible. The success of a well-designed logo is in how much it can say with as little as possible.

What is your personal design process?
1. Read the brief, reread the brief, and reread the brief again.
2. Think for about three days—at work, on the train, and in bed.
3. Make marks, write words, do research.
4. Distill three (minimum) different ways of answering the brief—clients generally expect a minimum of three routes.
5. Finesse, finesse, and finesse some more.
6. Road test logos by applying them to at least three diverse items.
7. Present to client when all is watertight.

What lessons have you learned about logo design or what do you wish you had known?
In logo design, it is important to be relevant, appropriate, and innovative.

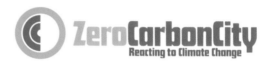

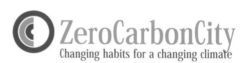

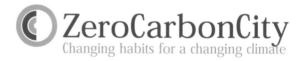

During the process, the layout of the slogan under the name,
and in a proportionately smaller size, was dismissed for being
too corporate and conventional. In response, Intro proposed a
fuller slogan that would match the logo's strength, rather than
merely underscore it.

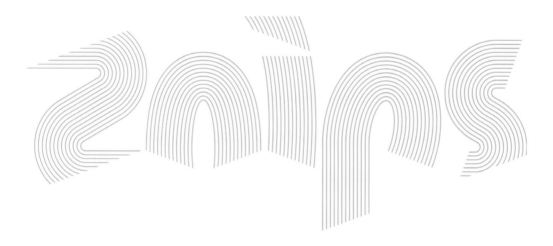

Znips

This original typeface, which gives life and movement to the Znips logo, was inspired by a font that its creators found in a punk fanzine from the eighties. From that snippet, they created a stylized representation of strands of hair. Znips is a beauty and hairdressing salon located in central London, and it wanted to convey an image with instinctive and immediate associations to hair—their raison d'etre. The action of the wind whipping through hair and the rough cut of scissors are evident in this winding font.

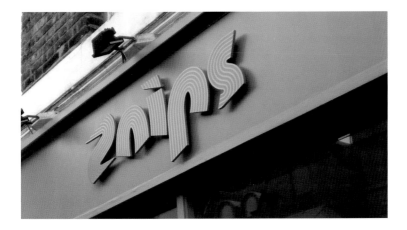

Mind Design

Mind Design is an independent London-based graphic design studio founded in 1999 by RCA graduate Holger Jacobs. Mind Design focuses on integrated design which combines corporate identity, print, web, and interior design.

www.minddesign.co.uk

What are the basic rules of logo design?
The design of a logo does not always have to be simple, but it should be stripped of everything that is unnecessary and sends confusing messages.

Where did you draw inspiration from for this project?
Znips was inspired by cut-and-paste lettering we found in an old punk fanzine.

What lessons have you learned about logo design or what do you wish you had known?
Most of our logo designs happen in the process of "making." They often are the result of just playing with forms or inspiration, rather than through strategic concept development. Typographic logos are always trying to regain an emotional aspect that is lost in our functional writing system, so why not trust emotions more? I always wonder why there is so much discussion in the corporate design world about something that should be more intuitive and that does not always follow a planned or structured process. I just wish I were better able to sell this approach to our clients.

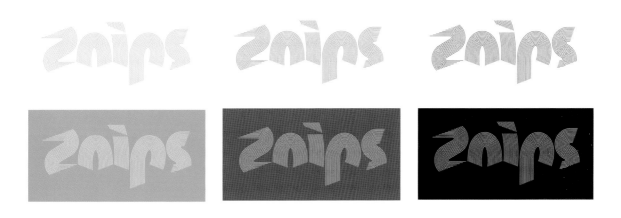

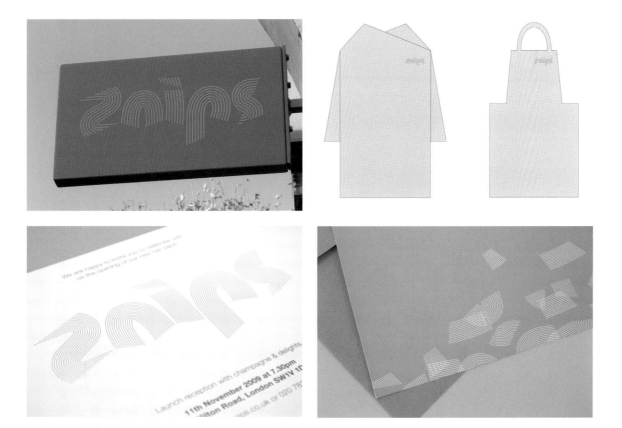

To decorate the Znips salon, a large mural was designed using an image from book cut-outs resembling tufts of hair and reinforcing their new brand identity.